*Happy Anniversary!!*  *Nov.'93*

# ART & NATURE

*An Illustrated Anthology of Nature Poetry*

Dear Ruth and Murray,

   May this collection of
Art and Poetry offer many
more joyous moments, to further
enrich your wonderful, happy
life together, for many, many years.

   With so much love,

   Roz

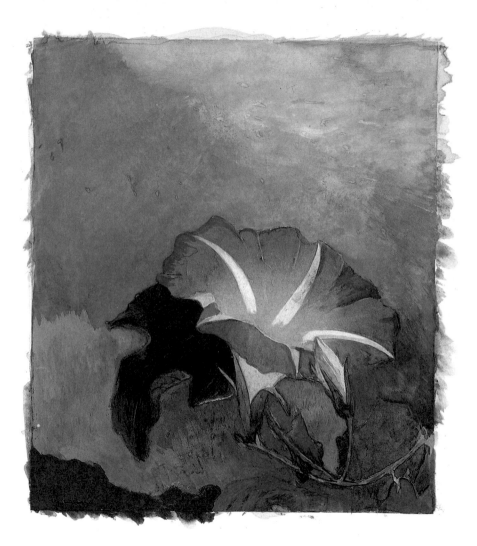

# ART & NATURE

## An Illustrated Anthology of Nature Poetry

Selected and Introduced by KATE FARRELL

The Metropolitan Museum of Art · New York

A Bulfinch Press Book / Little, Brown and Company

Boston · Toronto · London

FRONT JACKET: *Wild Roses and Irises* (detail). John La Farge, American, 1835–1910. Gouache and watercolor on paper, 1887. Gift of Priscilla A. B. Henderson, 1950, in memory of her grandfather, Russell Sturgis, a founder of The Metropolitan Museum of Art   50.113.3

BACK JACKET: *Cypresses*. Vincent van Gogh, Dutch, 1853–1890. Oil on canvas, 1889. Rogers Fund, 1949   49.30

FRONT COVER: *Butterflies and Grasses*. Paper stencil, Japanese, 19th century. Gift of Leon Dabo, 1955   55.175.39

ENDPAPERS: *Rose and Thistle*. William Morris, British, 1834–1896. Detail of a printed cotton, designed before April 1881. Purchase, Edward C. Moore, Jr. Gift, 1923   23.163.9

PAGE 2: *A Nocturne*. John La Farge, American, 1835–1910. Watercolor, gouache, and charcoal on paper, ca. 1885. Bequest of Louise Veltin, 1937   37.104

PAGE 13: *Landscape: The Parc Monceau*. Claude Monet, French, 1840–1926. Oil on canvas, 1876. Bequest of Loula D. Lasker, New York City, 1961   59.206

PAGE 51: *Study for "A Sunday on La Grande Jatte."* Georges Seurat, French, 1859–1891. Oil on canvas, 1884. Bequest of Sam A. Lewisohn, 1951   51.112.6

PAGE 93: *Autumn Oaks*. George Inness, American, 1825–1894. Oil on canvas. Gift of George I. Seney, 1887   87.8.8

PAGE 123: *Haystacks (Effect of Snow and Sun)*. Claude Monet, French, 1840–1926. Oil on canvas, 1891. Bequest of Mrs. H. O. Havemeyer, 1929, H. O. Havemeyer Collection   29.100.109

Once again, I am grateful for the careful eyes and the indispensable encouragement and advice of Mary Beth Brewer, my editor in the Department of Special Publications. Many thanks also to Elizabeth Stoneman, who expertly guided the book's production, and to Rachel Mustalish, who meticulously organized a multitude of details.                                    *Kate Farrell*

Compilation and introduction copyright © 1992 by Kate Farrell
Illustrations copyright © 1992 by The Metropolitan Museum of Art   All rights reserved

First Edition
First Printing

ISBN 0-87099-646-0 (MMA)
ISBN 0-8212-1979-0 (Bulfinch Press—distributor)

Library of Congress Catalog Card Number 92-50382
Library of Congress Cataloguing-in-Publication information is available.

PUBLISHED BY
The Metropolitan Museum of Art and Bulfinch Press
    Bulfinch Press is an imprint and trademark of
    Little, Brown and Company (Inc.)
    Published simultaneously in Canada by
    Little, Brown & Company (Canada) Limited
Produced by the Department of Special Publications,
    The Metropolitan Museum of Art
Photography on the back jacket and on pages 16, 21, 48 (bottom), 54, 102, 123, 126, 141, and 153 by Malcolm Varon, N.Y.C.; pages 63 and 119 by Geoffrey Clements; pages 118 and 154 (top) by Lynton Gardiner. All other photography by The Metropolitan Museum of Art Photograph Studio
Designed by Mary Ann Joulwan
Printed and bound in Italy by A. Mondadori, Verona

*We receive but what we give,*
*And in our life alone does Nature live.*

SAMUEL T. COLERIDGE

# CONTENTS

## Winter Paradise   123

# INTRODUCTION

"The poetry of earth is ceasing never," wrote John Keats in his classic poem "The Grasshopper and the Cricket." For Keats, nature was living poetry, and poetry best expressed nature's majesty, mystery, and ever-changing beauty. Nature has always inspired poets and artists, and, again and again, their works have captured the thrill of the earth's poetic moments—from the daily spectacle of the sun's rising and setting to the annual miracle of summer leaves turning gold in the fall or new spring buds sprouting from an old winter tree. This book—which matches nature poetry with artistic treasures from the collections of The Metropolitan Museum of Art—offers admirers of art, nature, and poetry an opportunity to enjoy the combined magic of all three.

For the most part, I chose the poetry first, then looked for works of art that would help bring it to life in a reader's imagination. From the vast store of poems about nature, I selected those that would show the marvelous diversity of both poetry and nature, while allowing a lively sequence of voices and images.

There are poems about animals and plants; poems about land, sea, and sky; poems about nature, wild and tame, sublime and ordinary. While the main subject is nature, the poetry sheds light on human nature, too. Poems such as "Reading the Book of Hills and Seas" by the fourth-century poet T'ao Ch'ien delight in the harmony between the poet and the natural world. In other poems, the poet's mood differs from the one outside the window: Ron Padgett describes feeling warm, safe, and loved despite a dark winter rain. D. H. Lawrence praises elephant courtship in a poem that makes human romance seem uncivilized by comparison, and in "Ars Poetica" Jorge Luis Borges sees in a river the flow of human life and

the reason for poetry. In "Docility" by Jules Supervielle, a disappointed forest reports sacrificing itself for ungrateful people, and Denise Levertov's "For the New Year, 1981" invites us to learn from the way irises grow how to spread hope around. The love of nature implicit in all the poetry and art seems an eloquent reminder of the importance of taking good care of the earth.

The order of the poems mirrors the course of the year, and the book's four sections—"Spring, the Sweet Spring," "Summer!," "Fall, Leaves, Fall," and "Winter Paradise"—each contain poems that seem to belong, literally or in spirit, to the season named. Sometimes an image depicts a poem's seasonal setting; at other times, it illustrates another aspect of the poem. And a few poems would fit as well in one section as another. Section titles come from the first poem in the section, and the book begins and ends with early spring.

Keats thought that, whether expressed by a grasshopper's voice in summer or by a cricket's song in winter, nature is an eternal poem that naturally inspires a poetic response. I hope that this book conveys this double sense of "the poetry of earth" and that turning its pages reflects something of the endless beauty and mystery of the days and nights of the turning year.

*Kate Farrell*

# Spring, the Sweet Spring

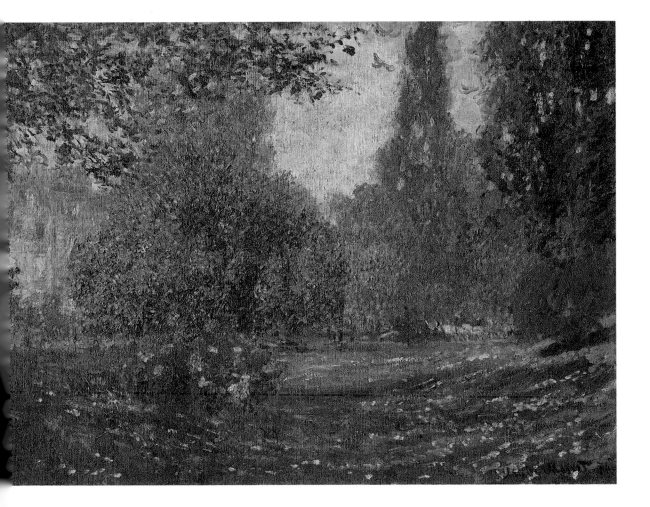

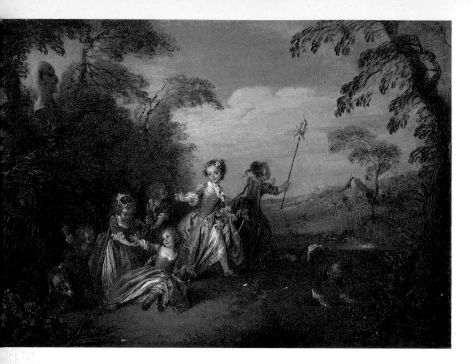

## IT'S SPRING!

Spring unfurls its blue ribbon
To flutter in the air again;
Sweet, familiar breezes
Brush the earth with promises.
Violets, already dreaming,
Are eager to arrive.
Listen—a harp in the distance!
Yes! It's you, Spring!
I knew you were coming!

<div align="right">

EDUARD MÖRIKE, German,
1804–1875

</div>

**The Golden Age.**
Jean Baptiste Joseph Pater, French,
1695–1736. Oil on wood.

## SPRING, THE SWEET SPRING

Spring, the sweet spring, is the year's pleasant
   king;
Then blooms each thing, then maids dance in a
   ring,
Cold doth not sting, the pretty birds do sing:
     Cuckoo, jug-jug, pu-we, to-witta-woo!

The palm and may make country houses gay,
Lambs frisk and play, the shepherds pipe all day,
And we hear aye birds tune this merry lay:
     Cuckoo, jug-jug, pu-we, to-witta-woo!

The fields breathe sweet, the daisies kiss our feet,
Young lovers meet, old wives a-sunning sit,
In every street these tunes our ears do greet:
     Cuckoo, jug-jug, pu-we, to-witta-woo!
      Spring, the sweet spring!

THOMAS NASHE, English, 1567–1601

## METAMORPHOSIS

Always it happens when we are not there—
The tree leaps up alive into the air,
Small open parasols of Chinese green
Wave on each twig. But who has ever seen
The latch sprung, the bud as it burst?
Spring always manages to get there first.

Lovers of wind, who will have been aware
Of a faint stirring in the empty air,
Look up one day through a dissolving screen
To find no star, but this multiplied green,
Shadow on shadow, singing sweet and clear.
Listen, lovers of wind, the leaves are here!

    MAY SARTON, American, b. 1912

## SONG OF SONGS

My beloved spake, and said unto me,
Rise up, my love, my fair one and come away.
For, lo, the winter is past,
  the rain is over and gone;
  the flowers appear on the earth;
  the time of the singing of birds is come,
  and the voice of the turtle is heard in our land;
  the fig tree putteth forth her green figs,
  and the vines with the tender grape give a good
     smell.
Arise, my love, my fair one, and come away.

    THE SONG OF SOLOMON, 2:10–13

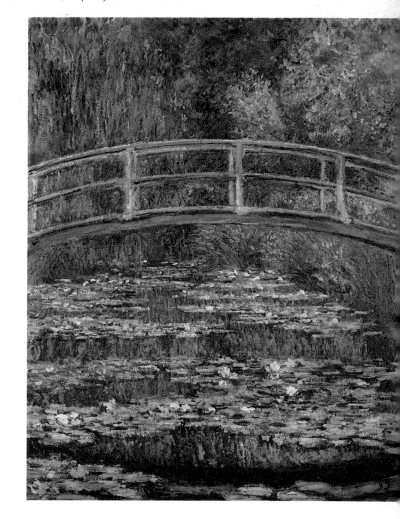

**Bridge over a Pool of Water Lilies.** Claude Monet, French, 1840–1926. Oil on canvas.

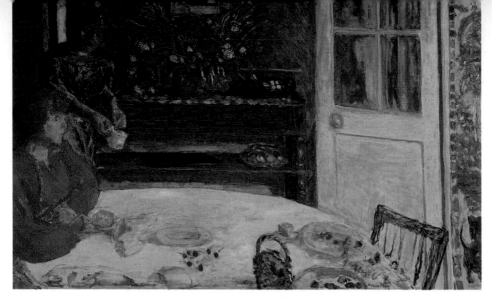

**The Dining Room, Vernonnet.** Pierre Bonnard, French, 1867–1947. Oil on canvas, ca. 1916.

### SPRING MORNING

Ah, through the open door
Is there an almond-tree
Aflame with blossom!
    —Let us fight no more.

Among the pink and blue
Of the sky and the almond flowers
A sparrow flutters.
    —We have come through,

It is really spring!—See,
When he thinks himself alone
How he bullies the flowers.
    —Ah, you and me

How happy we'll be!—See him?
He clouts the tufts of flowers
In his impudence.
    —But, did you dream

It would be so bitter? Never mind,
It is finished, the spring is here.
And we're going to be summer-happy
    And summer-kind.

We have died, we have slain and been slain,
We are not our old selves any more.
I feel new and eager
    To start again.

It is gorgeous to live and forget.
And to feel quite new.
See the bird in the flowers?—he's making
    A rare to-do!

He thinks the whole blue sky
Is much less than the bit of blue egg
He's got in his nest—we'll be happy,
    You and I, I and you.

With nothing to fight any more—
In each other, at least.
See, how gorgeous the world is
    Outside the door!

D. H. LAWRENCE, English, 1885–1930

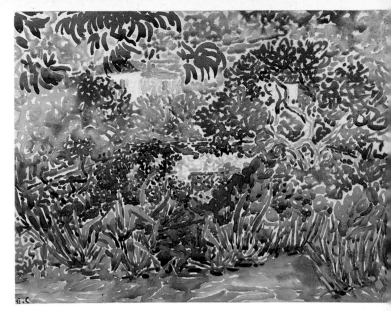

**The Artist's Garden at St. Clair.** Henri-Edmond Cross,
French, 1856–1910. Watercolor.

## DECIDUOUS SPRING

Now, now, the world
All gabbles joy like geese, for
An idiot glory the sky
Bangs. Look!
All leaves are new, are
*Now*, are
Bangles dangling and
Spangling, in sudden air
Wangling, then
Hanging quiet, bright.

The world comes back, and again

Is gabbling, and yes,
Remarkably worse, for
The world is a whirl of
Green mirrors gone wild with
Deceit, and the world
Whirls green on a string, then
The leaves go quiet, wink
From their own shade, secretly.

Keep still, just a moment, leaves.

There is something I am trying to remember.

ROBERT PENN WARREN, American, 1905–1989

## SAILING HOMEWARD

Cliffs that rise a thousand feet
Without a break,
Lake that stretches a hundred miles
Without a wave,
Sands that are white through all the year,
Without a stain,
Pine-tree woods, winter and summer
Ever-green,

Streams that for ever flow and flow
Without a pause,
Trees that for twenty thousand years
Your vows have kept,
You have suddenly healed the pain of a traveller's
heart,
And moved his brush to write a new song.

CHAN FANG-SHÊNG, Chinese, 5th century

## FIRST DAYS OF SPRING

First days of spring—the sky
is bright blue, the sun huge and warm.
Everything's turning green.
Carrying my monk's bowl, I walk to the village
to beg for my daily meal.
The children spot me at the temple gate
and happily crowd around,
dragging at my arms till I stop.
I put my bowl on a white rock,
hang my bag on a branch.
First we braid grasses and play tug-of-war,
then we take turns singing and keeping a kick-ball
     in the air:
I kick the ball and they sing, they kick and I sing.
Time is forgotten, the hours fly.
People passing by point at me and laugh:
"Why are you acting like such a fool?"
I nod my head and don't answer.
I could say something, but why?
Do you want to know what's in my heart?
From the beginning of time: just this! just this!

    Ryōkan, Japanese, 1758–1831

**Peach Blossom Spring.** Fan Ch'i, Chinese,
1616–after 1694. Leaf from the album *Landscapes*, 1646;
ink and color on paper.

**Mantel Clock with Figure of Pu-tai Ho-shang.**
Julien Le Roy, French, 1686–1759. Chantilly porcelain
figure, with flowers of soft- and hard-paste porcelain, on
a gilt-bronze base, ca. 1745–49.

## YOU ASK WHY

You ask why I make my home in the mountain
     forest,
and I smile, and am silent,
and even my soul remains quiet:
it lives in the other world
which no one owns.
The peach trees blossom.
The water flows.

    Li-Po, Chinese, 705–762

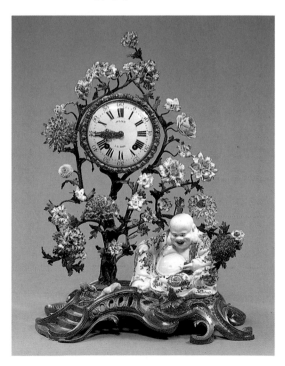

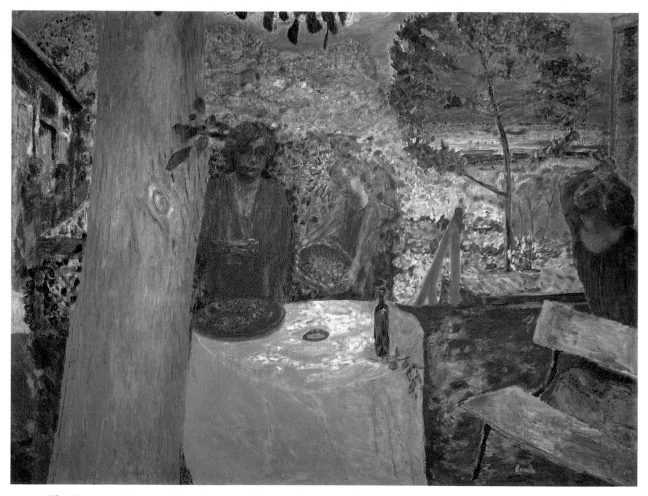

**The Terrace at Vernon.** Pierre Bonnard, French, 1867–1947. Oil on canvas, 1939.

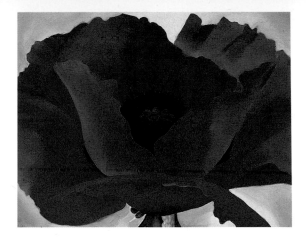

**Red Poppy.** Georgia O'Keeffe, American, 1887–1986. Oil on canvas, 1927.

## PHILOSOPHY IN WARM WEATHER

Now all the doors and windows
are open, and we move so easily
through the rooms. Cats roll
on the sunny rugs, and a clumsy wasp
climbs the pane, pausing
to rub a leg over her head.

All around physical life reconvenes.
The molecules of our bodies must love
to exist: they whirl in circles
and seem to begrudge us nothing.
Heat, Horatio, *heat* makes them
put this antic disposition on!

This year's brown spider
sways over the door as I come
and go. A single poppy shouts
from the far field, and the crow,
beyond alarm, goes right on
pulling up the corn.

JANE KENYON, American, b. 1947

## BOUQUETS

One flower at a time, please
however small the face.

Two flowers are one flower
too many, a distraction.

Three flowers in a vase begin
to be a little noisy.

Like cocktail conversation,
everybody talking.

A crowd of flowers is a crowd
of flatterers (forgive me).

One flower at a time. I want
to hear what it is saying.

ROBERT FRANCIS, American, b. 1901

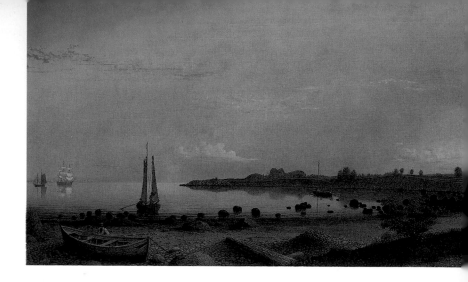

**Stage Fort Across Gloucester Harbor.**
Fitz Hugh Lane,
American, 1804–1865.
Oil on canvas, 1862.

## SUNSET

Fold upon fold of light,
Half-heaven of tender fire,
Conflagration of peace,
Wide hearth of the evening world.
How can a cloud give peace,
Peace speak through bodiless fire
And still the angry world?

Yet now each bush and tree
Stands still within the fire,
And the bird sits on the tree.
Three horses in a field
That yesterday ran wild
Are bridled and reined by light
As in a heavenly field.
Man, beast and tree in fire,
The bright cloud showering peace.

EDWIN MUIR, Scottish, 1887–1959

## THE END OF THE DAY

Oh who is
so cosy with
despair and
all, they will

not come,
rejuvenated, to
the last spectacle
of the day. Look!

the sun is
sinking, now
it's
gone. Night,

good and sweet
night, good
night, good, good
night, has come.

ROBERT CREELEY,
American, b. 1926

**Wild Geese Flying Down Across the Moon.**
Utagawa Hiroshige, Japanese, 1797–1858.
Woodblock print in colors, ca. 1833.

[ 22 ]

## AN EVENING WHEN THE FULL MOON ROSE AS THE SUN SET

April 11, 1976

The sun goes down in the dusty April night.
"You know it could be alive!"
The sun is round, massive, compelling, sober,
    on fire.
It moves swiftly through the tree stalks of the
    Lundin grove as we drive past. . . .
The legs of a bronze god walking at the edge of
    the world, unseen by many,
On his archaic errands, doubled up on his own
    energy.
He guides his life by his dreams;
When we look again he is gone.

Turning toward Milan, we see the other one, the
    moon, whole and rising.
Three wild geese make dark spots in that part of
    the sky.
Under the shining one the pastures leap forward,
Grass fields rolling as in October, the sow-colored
    fields near the river.
This rising one lights the pair of pintails alert in
    the shallow pond.
It shines on those faithful to each other, alert in
    the early night.
And the life of faithfulness goes by like a river,
With no one noticing it.

    ROBERT BLY, American, b. 1926

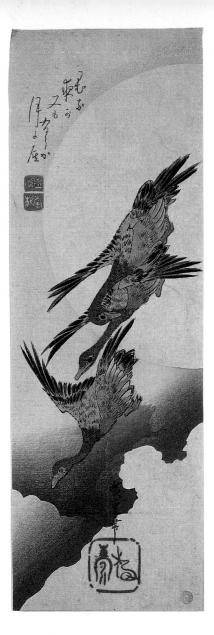

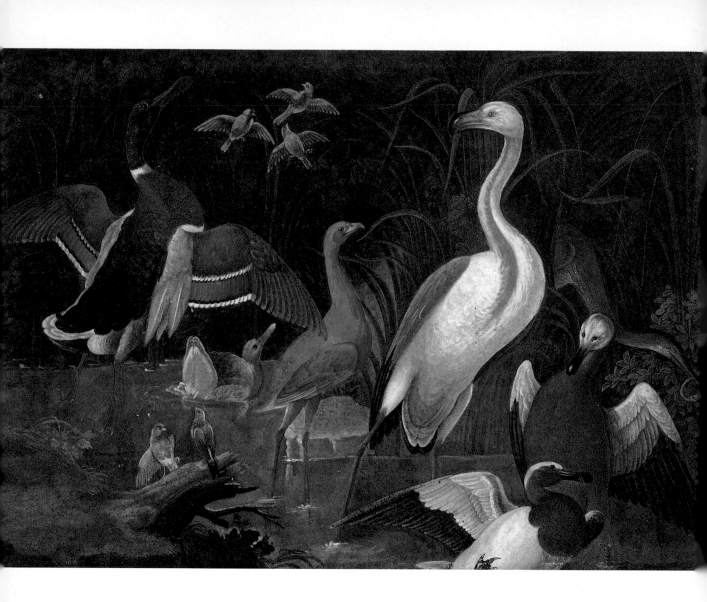

**Aquatic Birds at a Pool.**
Miniature from an album. Indian (Mughal period),
18th century. Ink, colors, and gold on paper.

## THE BIRD

Adventurous bird walking upon the air,
Like a schoolboy running and loitering, leaping
  and springing,
Pensively pausing, suddenly changing your mind
To turn at ease on the heel of a wing-tip. Where
In all the crystalline world was there to find
For your so delicate walking and airy winging
A floor so perfect, so firm and so fair,
And where a ceiling and walls so sweetly ringing,
Whenever you sing, to your clear singing?

The wide-winged soul itself can ask no more
Than such a pure, resilient and endless floor
For its strong-pinioned plunging and soaring and
  upward and upward springing.

  EDWIN MUIR, Scottish, 1887–1959

## THE PEACE OF WILD THINGS

When despair for the world grows in me
and I wake in the night at the least sound
in fear of what my life and my children's lives may
  be,
I go and lie down where the wood drake
rests in his beauty on the water, and the great
  heron feeds.
I come into the peace of wild things
who do not tax their lives with forethought
of grief. I come into the presence of still water.
And I feel above me the day-blind stars
waiting with their light. For a time
I rest in the grace of the world, and am free.

  WENDELL BERRY, American, b. 1934

## ETERNITY

He who binds to himself a joy
Does the winged life destroy;
But he who kisses the joy as it flies
Lives in eternity's sun rise.

  WILLIAM BLAKE, English, 1757–1827

# PERFECTION

The wind blows gently, fresh and cool.
The porch is fragrant with damp pine.
A duck stretches its wings wide,
having just laid its egg.

And it looks like a faultless girl,
having laid in God's design,
a perfection of white roundness
on an altar of straw.

And above the muddy, thawing road,
above the moldering roofs of the huts,
the perfection of the disk of fire
rises  slowly in the sky.

The perfection of the woods in spring
all shot through by the dawn,
almost disembodied, shimmers in mist
like the breath of the earth, all over the earth.

Not in the frantic shapes of new fashions,
not in shapes borrowed from others—
perfection is simply being natural,
perfection is the breath of the earth.

Don't torment yourself that art is secondary,
destined only to reflect,
that it remains so limited and lean,
compared with nature itself.

Without acting a part
look to yourself for the source of art,
and quietly and uniquely
reproduce yourself just as you are.

Be reflected, as a creation of nature
bending over a well
draws the reflection of its face
up from the ice-ringed depths.

YEVGENY YEVTUSHENKO, Russian, b. 1933

**Morning on the Seine near Giverny.**
Claude Monet, French, 1840–1926.
Oil on canvas, 1897.

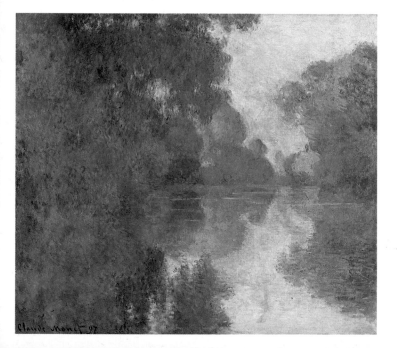

**Landscape, Fruit and Flowers.**
Frances Flora Bond Palmer, American, ca. 1812–1876,
for Currier and Ives. Hand-colored lithograph, 1862.

## THE SMELL OF BLUE GRAPES IS SWEET...

The smell of blue grapes is sweet . . .
The intoxicating view tantalizes.
Your voice is hollow and cheerless,
But I'm not feeling sorry for anyone, not anyone.

There are spiderwebs among the berries,
The stems of the supple vines are still thin,
Like little ice floes, little ice floes,

In the gleaming water of the sky-blue river,
  clouds swim.

The sun is in the sky. The sun brightly shines.
Go whisper to the wave what's amiss.
Oh, it will certainly reply,
And perhaps it will give you a kiss.

ANNA AKHMATOVA, Russian, 1889–1966

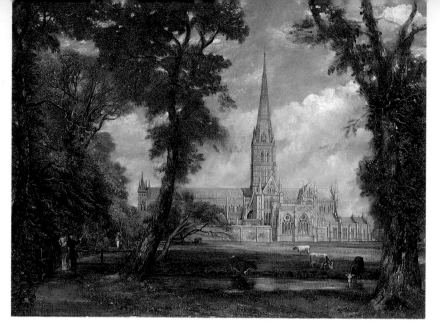

**Salisbury Cathedral from the Bishop's Grounds.**
John Constable, British,
1776–1837. Oil on canvas.

## HOME-THOUGHTS, FROM ABROAD

O to be in England
Now that April's there,
And whoever wakes in England
Sees, some morning, unaware,
That the lowest boughs and the brushwood sheaf
Round the elm-tree bole are in tiny leaf,
While the chaffinch sings on the orchard bough
In England—now!
And after April, when May follows,
And the whitethroat builds, and all the swallows!
Hark, where my blossom'd pear-tree in the hedge

Leans to the field and scatters on the clover
Blossoms and dewdrops—at the bent spray's
    edge—
That's the wise thrush; he sings each song twice
    over,
Lest you should think he never could recapture
The first fine careless rapture!
And though the fields look rough with hoary dew,
All will be gay when noontide wakes anew
The buttercups, the little children's dower
—Far brighter than this gaudy melon-flower!

ROBERT BROWNING, English, 1812–1889

## LOVELIEST OF TREES,
## THE CHERRY NOW

Loveliest of trees, the cherry now
Is hung with bloom along the bough,
And stands about the woodland ride
Wearing white for Eastertide.

Now, of my threescore years and ten,
Twenty will not come again,
And take from seventy springs a score,
It only leaves me fifty more.

And since to look at things in bloom
Fifty springs are little room,
About the woodlands I will go
To see the cherry hung with snow.

A. E. HOUSMAN, English, 1859–1936

**Spring Landscape.** Robert Blum, American,
1857–1903. Pastel on sandpaper.

## CHERRY BLOSSOMS

Cherry blossoms—
lights
of years past.

BASHŌ, Japanese, 1644–1694

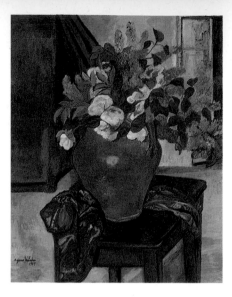

## WARBLE FOR LILAC-TIME

Warble me now for joy of lilac-time, (returning in
    reminiscence,)
Sort me O tongue and lips for Nature's sake,
    souvenirs of earliest summer,
Gather the welcome signs, (as children with
    pebbles or stringing shells,)
Put in April and May, the hylas croaking in the
    ponds, the elastic air,
Bees, butterflies, the sparrow with its simple
    notes,
Blue-bird and darting swallow, nor forget the
    high-hole flashing his golden wings,
The tranquil sunny haze, the clinging smoke, the
    vapor,
Shimmer of waters with fish in them, the cerulean
    above,
All that is jocund and sparkling, the brooks
    running,
The maple woods, the crisp February days and
    the sugar-making,
The robin where he hops, bright-eyed, brown-
    breasted,
With musical clear call at sunrise, and again at
    sunset,
Or flitting among the trees of the apple-orchard,
    building the nest of his mate,
The melted snow of March, the willow sending
    forth its yellow-green sprouts,
For spring-time is here! the summer is here! and
    what is this in it and from it?
Thou, soul, unloosen'd—the restlessness after I
    know not what;
Come, let us lag here no longer, let us be up and
    away!
O if one could but fly like a bird!
O to escape, to sail forth as in a ship!
To glide with thee O soul, o'er all, in all, as a ship
    o'er the waters;
Gathering these hints, the preludes, the blue sky,
    the grass, the morning drops of dew,
The lilac-scent, the bushes with dark green
    heart-shaped leaves,
Wood-violets, the little delicate pale blossoms
    called innocence,
Samples and sorts not for themselves alone, but
    for their atmosphere,
To grace the bush I love—to sing with the birds,
A warble for joy of lilac-time, returning in
    reminiscence.

WALT WHITMAN, American, 1819–1892

## MAGNA EST VERITAS

Here, in this little Bay,
Full of tumultuous life and great repose,
Where, twice a day,
The purposeless, glad ocean comes and goes,
Under high cliffs, and far from the huge town,
I sit me down.
For want of me the world's course will not fail;
When all its work is done, the lie shall rot;
The truth is great, and shall prevail,
When none cares whether it prevail or not.

COVENTRY PATMORE, English, 1823–1896

## THE WIND BLOWS FROM THE SEA

By the sandy water I breathe in the odor of the sea;
From there the wind comes and blows over the
world.
By the sandy water I breathe in the odor of the sea;
From there the clouds come and rain falls over the
world.

ANONYMOUS, Papago Indian

**Lilacs and Peonies.** Suzanne Valadon,
French, 1867–1938. Oil on canvas, 1929.

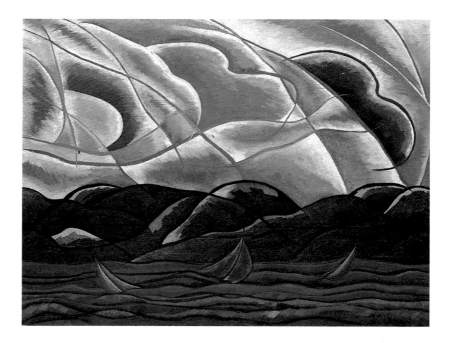

**Clouds and Water.**
Arthur Dove, American,
1880–1946. Oil on canvas,
1930.

## IN TIME OF SILVER RAIN

In time of silver rain
The earth
Puts forth new life again,
Green grasses grow
And flowers lift their heads,
And over all the plain
The wonder spreads
    Of life,
    Of life,
    Of life!

In time of silver rain
The butterflies
Lift silken wings
To catch a rainbow cry,
And trees put forth
New leaves to sing
In joy beneath the sky
As down the roadway
Passing boys and girls
Go singing, too,
In time of silver rain
    When spring
    And life
    Are new.

    LANGSTON HUGHES, American,
          1902–1967

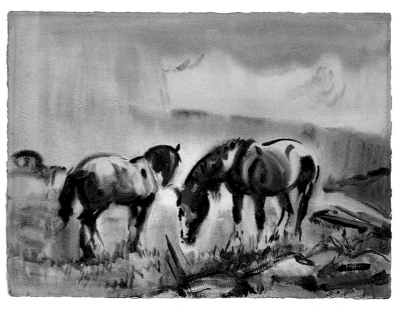

**Horses in the Rain.** Robert Noel Blair,
American, b. 1912. Watercolor on paper, 1939.

## PLOUGHING ON SUNDAY

The white cock's tail
Tosses in the wind.
The turkey-cock's tail
Glitters in the sun.

Water in the fields.
The wind pours down.
The feathers flare
And bluster in the wind.

Remus, blow your horn!
I'm ploughing on Sunday,
Ploughing North America.
Blow your horn!

Tum-ti-tum,
Ti-tum-tum-tum!
The turkey-cock's tail
Spreads to the sun.

The white cock's tail
Streams to the moon.
Water in the fields.
The wind pours down.

WALLACE STEVENS, American,
1879–1955

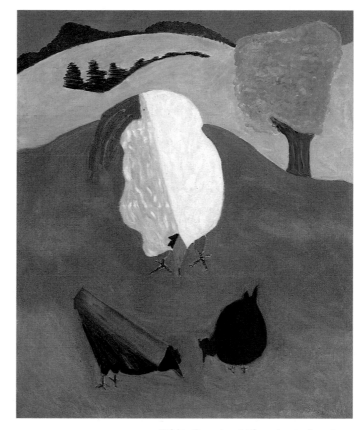

**White Rooster.** Milton Avery, American,
1885–1965. Oil on canvas, 1947.

## THE FIRST OF MAY

Now the smallest creatures, who do not know
    they have names,
In fields of pure sunshine open themselves and
    sing.
All over the marshes and in the wet meadows,
Wherever there is water, the companies of peepers
Who cannot count their members, gather with
    sweet shouting.
And the flowers of the woods who cannot see each
    other
Appear in perfect likeness of one another
Among the weak new shadows on the mossy
    places.

Now the smallest creatures, who know themselves
    by heart,
With all their tender might and roundness of
    delight
Spending their colors, their myriads and their
    voices
Praise the moist ground and every winking leaf,
And the new sun that smells of the new streams.

ANNE PORTER, American, b. 1911

**Alpine Pool.** John Singer Sargent,
American, 1856–1925. Oil on canvas.

## DOCILITY

The forest says, "I'm always the one who's
   sacrificed,
They harass me, they tramp all over me, they
   smash me with their axes,
They try to pick a quarrel with me, they torment
   me for no reason,
They fling birds at my head and ants at my legs
And they carve names in me for which I have no
   affection.
Ah, they know only too well that I can't defend
   myself
Like a horse that's provoked or a discontented
   cow,
Even though I always do what they tell me to do.
They ordered me, 'Take root!' And I gave as much
   root as I could.
'Make shade!' And I made as much of it as was
   reasonable.
'Stop making it in winter!' I dropped my leaves
   down to the last one.
Month by month and day by day I know perfectly
   well what I have to do,
But it's been a long time since they last needed to
   order me about.
Then why are these lumberjacks approaching in
   lockstep?
Let someone tell me what's expected of me and I'll
   do it.
Let someone answer me with a cloud or some sign
   in the sky.

**Dandelion Seed Balls and Trees.** Charles Burchfield,
American, 1893–1967. Watercolor, gouache, and pencil
on paper, 1917.

I'm not a rebel, I'm not looking to argue with
   anyone.
But just the same it seems to me it would be nice
   if they answered me
When the rising wind makes a questioner of me."

    JULES SUPERVIELLE, French, 1884–1960

## THE SKY RISES ABOVE THE ROOFTOP

The sky rises above the rooftop
    So blue, so calm!
A palm tree rises above the rooftop
    Rocking its fronds.

The bell in that sky up there
    Is softly ringing.
A bird on that branch up there
    Is tenderly singing.

My God, my God, life is there
    Simple and good.
That peaceful hum out there
    Comes from your neighborhood.

—What have you done, you over there,
    Always in tears,
Tell me, what have you done, you over there,
    With your young years?

PAUL VERLAINE, French, 1844–1896

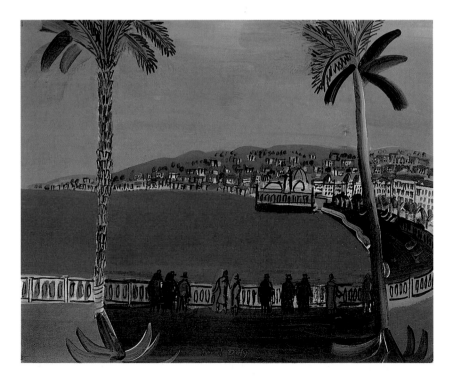

**Nice, La Baie des Anges.**
Raoul Dufy, French,
1877–1953. Oil on canvas,
1932.

## WISTERIA

The first purple wisteria
I recall from boyhood hung
on a wire outside the windows
of the breakfast room next door
at the home of Steve Pisaris.
I loved his tall, skinny daughter,
or so I thought, and I would wait
beside the back door, prostrate,
begging to be taken in. Perhaps
it was only the flowers of spring
with their sickening perfumes
that had infected me. When Steve
and Sophie and the three children
packed up and made the move west,
I went on spring after spring,
leaden with desire, half-asleep,
praying to die. Now I know
those prayers were answered.
That boy died, the brick houses
deepened and darkened with rain,
age, use, and finally closed
their eyes and dreamed the sleep
of California. I learned this
only today. Wakened early
in an empty house not lately
battered by storms, I looked
for nothing. On the surface
of the rain barrel, the paled,
shredded blossoms floated.

PHILIP LEVINE, American, b. 1928

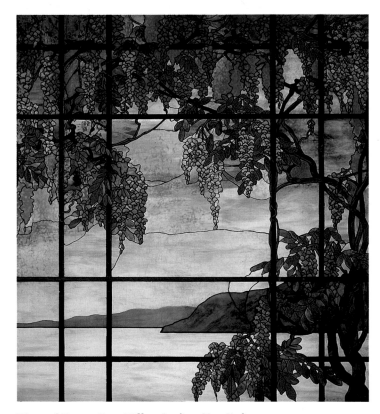

**View of Oyster Bay.** Tiffany Studios, New York.
Leaded-glass window from the William Skinner House,
New York City, ca. 1905.

## WILD FLOWERS

Beautiful mortals of the glowing earth
And children of the season crowd together
In showers and sunny weather
Ye beautiful spring hours
Sunshine and all together
    I love wild flowers

The rain drops lodge on the swallows wing
Then fall on the meadow flowers
Cowslips and enemonies all come with spring
Beaded with first showers
The skylarks in the cowslips sing
    I love wild flowers

Blue-bells and cuckoo's in the wood
And pasture cuckoo's too
Red yellow white and blue
Growing where herd cows meet the showers
And lick the morning dew
    I love wild flowers

The lakes and rivers— summer hours
All have their bloom as well
But few of these are childrens flowers
They grow where dangers dwell
In sun and shade and showers
    I love wild flowers

They are such lovely things
And make the very seasons where they come
The nightingale is smothered where she sings

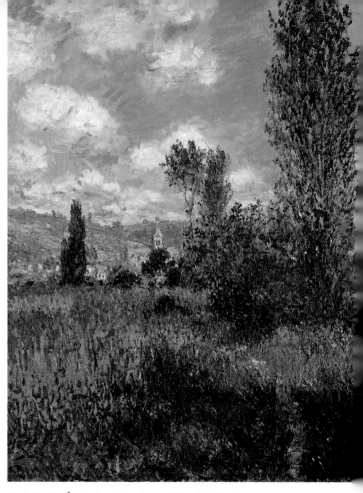

**Path in the Île Saint-Martin, Vétheuil.** Claude Monet,
French, 1840–1926. Oil on canvas, 1880.

Above their scented bloom
O what delight the cuckoo music brings
    I love wild flowers

    JOHN CLARE, English, 1793–1864

[ 38 ]

## ARE THEY NOT ALL
## MINISTERING SPIRITS?

We see them not—we cannot hear
    The music of their wing—
Yet know we that they sojourn near,
    The Angels of the spring!

They glide along this lovely ground
    When the first violet grows;
Their graceful hands have just unbound
    The zone of yonder rose.

I gather it for thy dear breast,
    From stain and shadow free:
That which an Angel's touch hath blest
    Is meet, my love, for thee!

    ROBERT STEVEN HAWKER, English, 1803–1875

**Les attitudes sont faciles et chastes.** Maurice Denis,
French, 1870–1943. Color lithograph from the suite
*Amour*, ca. 1899.

## THE BEST

What's the best thing in the world?
June-rose, by May-dew impearl'd;
Sweet south-wind, that means no rain;
Truth, not cruel to a friend;
Pleasure, not in haste to end;
Beauty, not self-deck'd and curl'd
Till its pride is over-plain;

Light, that never makes you wink;
Memory, that gives no pain;
Love, when, *so*, you're loved again.
What's the best thing in the world?
—Something out of it, I think.

    ELIZABETH BARRETT BROWNING,
               English, 1806–1861

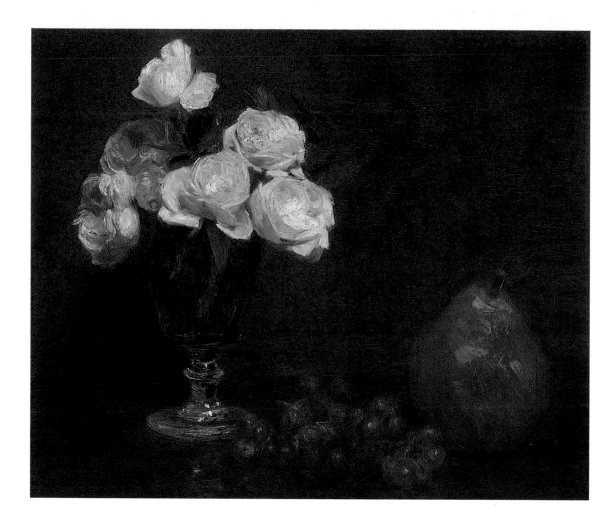

**Still Life with Roses and Fruit.**
Henri Fantin-Latour, French,
1836–1904. Oil on canvas, 1863.

## THE ACT

There were the roses, in the rain.
Don't cut them, I pleaded.
    They won't last, she said.
But they're so beautiful
    where they are.
Agh, we were all beautiful once, she
    said,
and cut them and gave them to me
    in my hand.

WILLIAM CARLOS WILLIAMS, American,
1883–1963

## CASIDA OF THE ROSE

    The rose
was not searching for the sunrise:
almost eternal on its branch,
it was searching for something else.

    The rose
was not searching for darkness or science:
borderline of flesh and dream,
it was searching for something else.

    The rose
was not searching for the rose.
Motionless in the sky
it was searching for something else.

FEDERICO GARCÍA LORCA, Spanish, 1898–1936

## ROSE, OH PURE CONTRADICTION

Rose, oh pure contradiction, joy
of being No-one's sleep under so many
lids.

RAINER MARIA RILKE, Austrian, 1875–1926

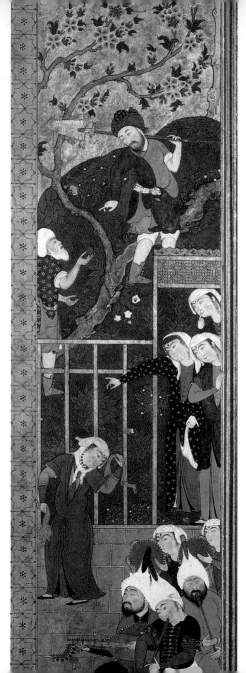

## PAGE FROM A JOURNAL

On the slope behind the house today
I cut through roots and rocks and
Dug a hole, deep and wide,
Carted away from it each stone
And all the friable, thin earth.
Then I knelt there a moment, walked
In the old woods, bent down again, using
A trowel and both my hands to scoop
Black, decaying woods-soil with the warm
Smell of fungi from the trunk of a rotting
Chestnut tree—two heavy buckets full I carried
Back to the hole and planted the tree inside;
Carefully I covered the roots with peaty soil,
Slowly poured sun-warmed water over them,
Mudding them gently until the soil settled.
It stands there, young and small,
Will go on standing when we are gone
And the huge uproar, endless urgency and
Fearful delirium of our days forgotten.

The föhn will bend it, rainstorms tear at it,
The sun will laugh, wet snow weigh it down,
The siskin and the nuthatch make it their home,
And the silent hedgehog burrow at its foot.
All it has ever experienced, tasted, suffered:
The course of years, generations of animals,
Oppression, recovery, friendship of sun and wind
Will pour forth each day in the song
Of its rustling foliage, in the friendly

Gesture of its gently swaying crown,
In the delicate sweet scent of resinous
Sap moistening the sleep-glued buds,
And in the eternal game of lights and
Shadows it plays with itself, content.

HERMANN HESSE, German, 1877–1962

**A Gardener.** Detail of a miniature, *The Wedding of Siyavush and Farangis*, from the *Shah-nameh* by Firdowsi, made for Shah Tahmasp. Persian, attributed to Qasim, son of 'Ali, supervised by Mir Musawir. Ink, colors, silver, and gold on paper, ca. 1525–30.

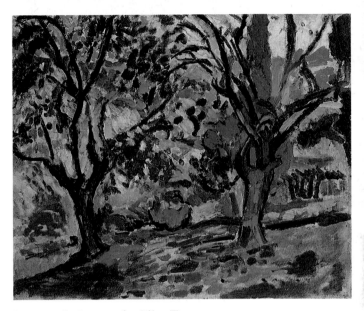

**Promenade Among the Olive Trees.**
Henri Matisse, French, 1869–1954. Oil on canvas.

## THE INFINITE

I've always liked this lonely hill
crowned with a thicket cutting from view
so great a part of the far horizon.
Sitting and gazing out, I can imagine
interminable spaces beyond, supernatural
silences, and that profound calm
in which the heart comes near
to terror. And as I hear

the wind flutter the branches around me,
I weigh its voice against that infinite
silence; and summon up Eternity,
the dead seasons, and the present one
alive with sound. And so in this Immensity
my thoughts drown; and I find how sweet
it is to shipwreck in that sea.

GIACOMO LEOPARDI, Italian, 1798–1837

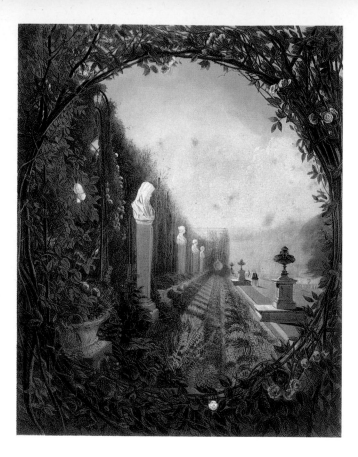

## THE GLORY OF THE GARDEN

Our England is a garden that is full of stately
   views,
Of borders, beds and shrubberies and lawns and
   avenues,
With statues on the terraces and peacocks strutting
   by;

But the Glory of the Garden lies in more than
   meets the eye.

For where the old thick laurels grow, along the
   thin red wall,
You will find the tool and potting sheds which are
   the heart of all;
The cold-frames and the hot-houses, the dungpits
   and the tanks,
The rollers, carts and drain-pipes, with the barrows
   and the planks.

And there you'll see the gardeners, the men and
   'prentice boys
Told off to do as they are bid and do it without
   noise;
For, except when seeds are planted and we shout
   to scare the birds,
The Glory of the Garden it abideth not in words.

And some can pot begonias and some can bud a
   rose,
And some are hardly fit to trust with anything
   that grows;
But they can roll and trim the lawns and sift the
   sand and loam,
For the Glory of the Garden occupieth all who
   come.

Our England is a garden, and such gardens are
   not made

By Singing:—"Oh, how beautiful!" and sitting in
  the shade,
While better men than we go out and start their
  working lives
At grubbing weeds from gravel-paths with broken
  dinner-knives.

There's not a pair of legs so thin, there's not a
  head so thick,
There's not a hand so weak and white, nor yet a
  heart so sick,
But it can find some needful job that's crying to be
  done,
For the Glory of the Garden glorifieth every one.

Then seek your job with thankfulness and work
  till further orders,

If it's only netting strawberries or killing slugs on
  borders;
And when your back stops aching and your hands
  begin to harden,
You will find yourself a partner in the Glory of the
  Garden.

Oh, Adam was a gardener, and God who made
  him sees
That half a proper gardener's work is done upon
  his knees,
So when your work is finished, you can wash your
  hands and pray
For the Glory of the Garden, that it may not pass
  away!
*And the Glory of the Garden it shall never pass away!*

Rudyard Kipling, English, 1865–1936

**The Trellis Window,
Trentham Hall Gardens,
the Seat of His Grace the
Duke of Sutherland,** from
*The Gardens of England* by E.
Adveno Brooke. Published in
London by T. McLean, 1857.
Chromolithograph.

**The Gardener.**
Georges Seurat, French,
1859–1891. Oil on wood,
1882–83.

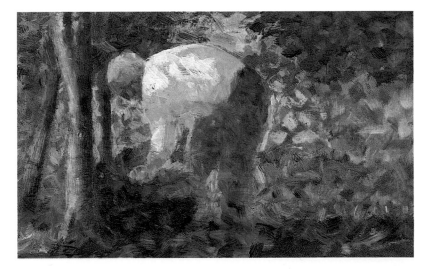

## THE CREATION OF THE ANIMALS

FROM PARADISE LOST

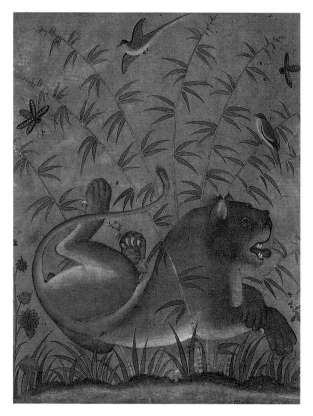

**A Lion at Rest.** Indian (Mughal, period of Akbar), ca. 1585. Ink, colors, silver, and gold on paper.

The sixth, and of creation last arose
With evening harps and matin, when God said,
Let the earth bring forth soul living in her kind,
Cattle and creeping things, and beast of the
    earth,
Each in their kind. The earth obeyed, and straight
Opening her fertile womb teemed at a birth
Innumerous living creatures, perfect forms,
Limbed and full grown: out of the ground up rose
As from his lair the wild beast where he wons
In forest wild, in thicket, brake, or den;
Among the trees in pairs they rose, they walked:
The cattle in the fields and meadows green:
Those rare and solitary, these in flocks
Pasturing at once, and in broad herds upsprung.
The grassy clods now calved, now half appeared
The tawny lion, pawing to get free
His hinder parts, then springs as broke from
    bonds,
And rampant shakes his brinded mane; the ounce,
The libbard, and the tiger, as the mole
Rising, the crumbled earth above them threw
In hillocks; the swift stag from underground
Bore up his branching head: scarce from his
    mould
Behemoth biggest born of earth upheaved
His vastness: fleeced the flocks and bleating rose,
As plants: ambiguous between sea and land
The river horse and scaly crocodile.

JOHN MILTON, English, 1608–1674

[ 46 ]

## THE TYGER

Tyger! Tyger! burning bright
In the forests of the night,
What immortal hand or eye
Could frame thy fearful symmetry?

In what distant deeps or skies
Burnt the fire of thine eyes?
On what wings dare he aspire?
What the hand dare sieze the fire?

And what shoulder, & what art,
Could twist the sinews of thy heart?
And when thy heart began to beat,
What dread hand? & what dread feet?

What the hammer? what the chain?
In what furnace was thy brain?
What the anvil? what dread grasp
Dare its deadly terrors clasp?

When the stars threw down their spears
And water'd heaven with their tears,
Did he smile his work to see?
Did he who made the Lamb make thee?

Tyger! Tyger! burning bright
In the forests of the night,
What immortal hand or eye
Dare frame thy fearful symmetry?

WILLIAM BLAKE, English, 1757–1827

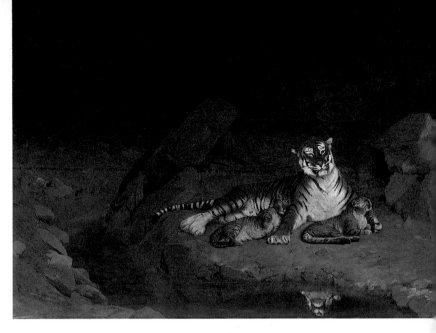

**Tiger and Cubs.** Jean-Léon Gérôme,
French, 1824–1904. Oil on canvas.

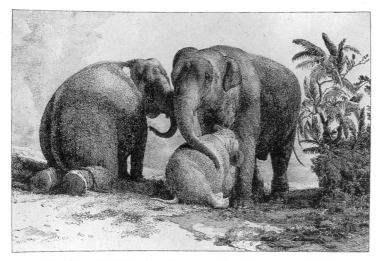

**Elephant Calf Nursing.** Engraving from *Histoire naturelle des deux éléphàns* . . . . Jean-Pierre-Louis-Laurent Houel, French, 1735–1813. Published in Paris, 1803.

## THE ELEPHANT IS SLOW TO MATE

The elephant, the huge old beast,
    is slow to mate;
he finds a female, they show no haste
    they wait

for the sympathy in their vast shy hearts
    slowly, slowly to rouse
as they loiter along the river-beds
    and drink and browse

and dash in panic through the brake
    of forest with the herd,
and sleep in massive silence, and wake
    together, without a word.

So slowly the great hot elephant hearts
    grow full of desire,
and the great beasts mate in secret at last,
    hiding their fire.

Oldest they are and the wisest of beasts
    so they know at last
how to wait for the loneliest of feasts
    for the full repast.

They do not snatch, they do not tear;
    their massive blood
moves as the moon-tides, near, more near,
    till they touch in flood.

D. H. LAWRENCE, English, 1885–1930

## TO THE UNSEEABLE ANIMAL

My daughter: *"I hope there's an animal*
*somewhere that nobody has ever seen.*
*And I hope nobody ever sees it."*

Being, whose flesh dissolves
at our glance, knower
of the secret sums and measures,
you are always here,
dwelling in the oldest sycamores,
visiting the faithful springs
when they are dark and the foxes
have crept to their edges.
I have come upon pools
in streams, places overgrown
with the woods' shadow,
where I knew you had rested,
watching the little fish
hang still in the flow;
as I approached they seemed

particles of your clear mind
disappearing among the rocks.
I have waked deep in the woods
in the early morning, sure
that while I slept
your gaze passed over me.
That we do not know you
is your perfection
and our hope. The darkness
keeps us near you.

WENDELL BERRY, American, b. 1934

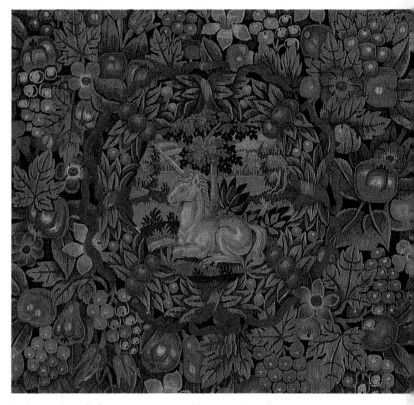

**Unicorn.** Detail of a tapestry-woven table carpet. Dutch, mid-17th century. Wool and silk.

**The Queen (Bird of Paradise).** Color aquatint with additional hand-coloring by R. Cooper, after the painting by Peter Charles Henderson, from *The Temple of Flora* by Dr. Robert John Thornton, London, 1799–1807.

[49]

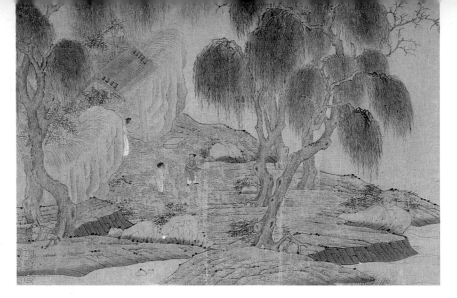

**Returning Home.**
Ch'ien Hsüan, Chinese,
ca. 1235–before 1307.
Detail of a handscroll;
ink and color on paper.

## READING THE BOOK OF HILLS AND SEAS

In the month of June the grass grows high
And round my cottage thick-leaved branches sway.
There is not a bird but delights in the place where
   it rests;
And I too—love my thatched cottage.
I have done my ploughing;
I have sown my seed.
Again I have time to sit and read my books.
In the narrow lane there are no deep ruts;
Often my friends' carriages turn back.
In high spirits I pour out my spring wine
And pluck the lettuce growing in my garden.
A gentle rain comes stealing up from the east
And a sweet wind bears it company.

My thoughts float idly over the story of the king
   of Chou,
My eyes wander over the pictures of Hills and
   Seas.
At a single glance I survey the whole Universe.
He will never be happy, whom such pleasures
   fail to please!

    T'AO CH'IEN, Chinese, 365–427

## SPRING SONG

As my eyes search the prairie
I feel the summer in the spring.

    ANONYMOUS, Chippewa Indian

*Summer!*

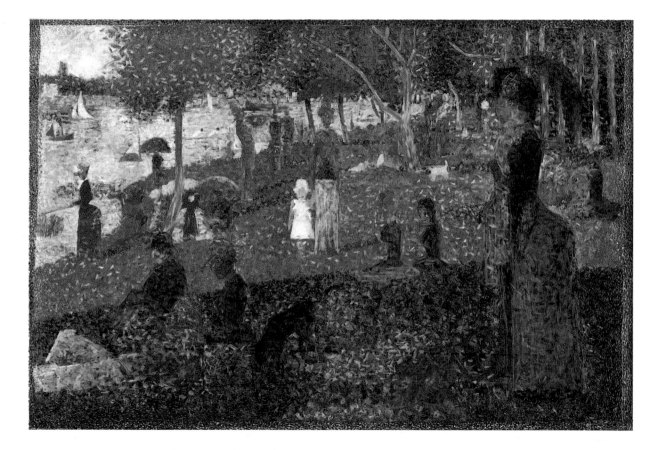

## THE CORN HARVEST

Summer!
the painting is organized
about a young

reaper enjoying his
noonday rest
completely

relaxed
from his morning labors
sprawled

in fact sleeping
unbuttoned
on his back

the women
have brought him his lunch
perhaps

a spot of wine
they gather gossiping
under a tree

whose shade
carelessly
he does not share the

resting
center of
their workaday world

WILLIAM CARLOS WILLIAMS,
American, 1883–1963

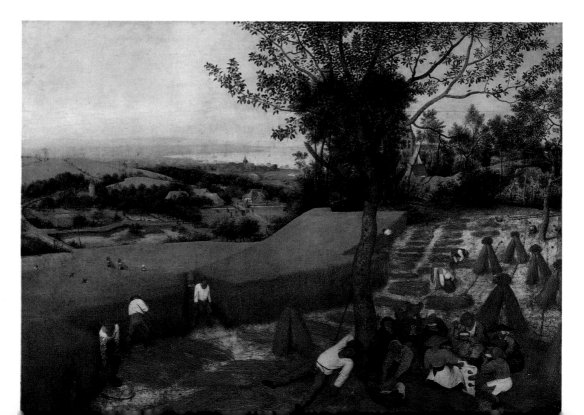

**E. J. Bowen Seed Catalogue.**
Emanuel Wyttenbach, American,
active 1857–1894. Color
lithograph, late 19th century.

**The Harvesters.** Pieter Bruegel
the Elder, Flemish, active by 1551,
died 1569. Oil on wood.

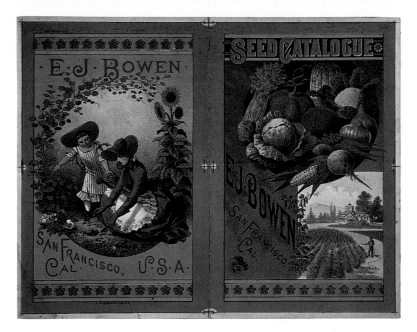

## SUMMER SOLSTICE

FROM WITHIN THE SEASONS

Come, bring the children. Let them
feel for a moment the rhythm
of the hoe. Let them experience
the wonder of green shoots emerging
    from earth, earth given us
in guardianship from the Creation.

Body, mind, and spirit full to bursting
with ripe, sweet berries, the first
tender green beans, and corn. We give

thanks, and thanks again. The twin
    concepts of Reason and Peace are
seen in each kernel of an ear of corn.

Perhaps we repair our lodges
as do the beavers living close by.
Our children swim like river otters
and as their laughter reaches us,
    we join them for a while
in these hottest of summer days.

PETER BLUE CLOUD (Aroniawenrate),
Mohawk Indian, b. 1935

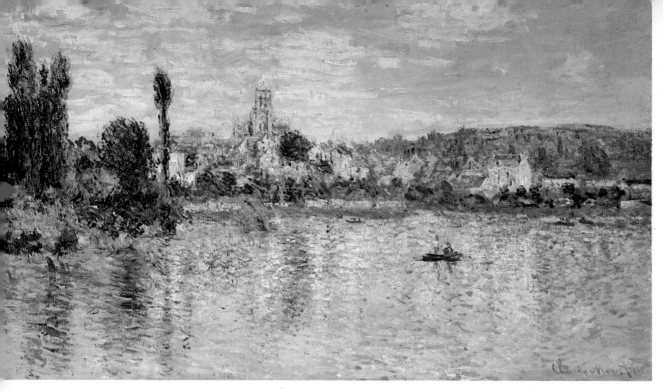

**Vétheuil in Summer.** Claude Monet,
French, 1840–1926. Oil on canvas, 1880.

## I THANK YOU GOD FOR MOST
## THIS AMAZING

i thank You God for most this amazing
day: for the leaping greenly spirits of trees
and a blue true dream of sky;and for everything
which is natural which is infinite which is yes

(i who have died am alive again today,
and this is the sun's birthday;this is the birth
day of life and of love and wings:and of the gay
great happening illimitably earth)

how should tasting touching hearing seeing
breathing any—lifted from the no
of all nothing—human merely being
doubt unimaginable You?

(now the ears of my ears awake and
now the eyes of my eyes are opened)

E. E. CUMMINGS, American, 1894–1962

[ 54 ]

## LIGHT, MY LIGHT,
## THE WORLD-FILLING LIGHT

Light, my light, the world-filling light, the
    eye-kissing light, heart-sweetening light!
Ah, the light dances, my darling, at the centre of
    my life; the light strikes, my darling, the
    chords of my love; the sky opens, the wind
    runs wild, laughter passes over the earth.
The butterflies spread their sails on the sea of
    light. Lilies and jasmines surge up on the crest
    of the waves of light.

The light is shattered into gold on every cloud,
    my darling, and it scatters gems in profusion.
Mirth spreads from leaf to leaf, my darling, and
    gladness without measure. The heaven's river
    has drowned its banks and the flood of joy is
    abroad.

RABINDRANATH TAGORE, Indian, 1861–1941

**Sun Spots.** John Marin, American, 1870–1953.
Watercolor and crayon on paper, 1920.

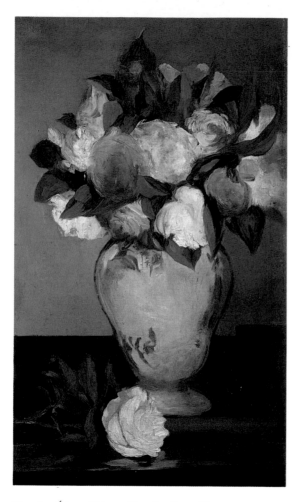

**Peonies.** Édouard Manet, French, 1832–1883.
Oil on canvas, 1864.

## AFTERGLOW

Peonies
The strange pink colour of Chinese porcelains;
Wonderful—the glow of them.
But, my Dear, it is the pale blue larkspur
Which swings windily against my heart.
Other Summers—
And a cricket chirping in the grass.

AMY LOWELL, American, 1874–1925

## BY THE PEONIES

The peonies bloom, white and pink.
And inside each, as in a fragrant bowl,
A swarm of tiny beetles have their conversation,
For the flower is given to them as their home.

Mother stands by the peony bed,
Reaches for one bloom, opens its petals,
And looks for a long time into peony lands,
Where one short instant equals a whole year.

Then lets the flower go. And what she thinks
She repeats aloud to the children and herself.
The wind sways the green leaves gently
And speckles of light flick across their faces.

CZESLAW MILOSZ, Polish, b. 1911

**The Monet Family in Their Garden.**
Édouard Manet, French, 1832–1883. Oil on canvas.

## HAPPINESS MAKES UP IN HEIGHT
## FOR WHAT IT LACKS IN LENGTH

O stormy, stormy world,
The days you were not swirled
Around with mist and cloud,
Or wrapped as in a shroud,
And the sun's brilliant ball
Was not in part or all
Obscured from mortal view—
Were days so very few
I can but wonder whence
I get the lasting sense
Of so much warmth and light.
If my mistrust is right

It may be altogether
From one day's perfect weather,
When starting clear at dawn
The day swept clearly on
To finish clear at eve.
I verily believe
My fair impression may
Be all from that one day
No shadow crossed but ours
As through its blazing flowers
We went from house to wood
For change of solitude.

ROBERT FROST, American, 1874–1963

## IN BEAUTY MAY I WALK

| | |
|---|---|
| In beauty | may I walk |
| All day long | may I walk |
| Through the returning seasons | may I walk |
| Beautifully will I possess again | |
| Beautifully birds | |
| Beautifully joyful birds | |
| On the trail marked with pollen | may I walk |
| With grasshoppers about my feet | may I walk |
| With dew about my feet | may I walk |
| With beauty | may I walk |
| With beauty before me | may I walk |
| With beauty behind me | may I walk |
| With beauty above me | may I walk |
| With beauty all around me | may I walk |

In old age, wandering on a trail
                    of beauty, lively, may I walk
In old age, wandering on a trail
                    of beauty, living again, may I walk
It is finished in beauty
It is finished in beauty

ANONYMOUS, Navajo Indian

## GREAT THINGS ARE DONE

Great things are done when men and mountains
    meet;
This is not done by jostling in the street.

WILLIAM BLAKE, English, 1757–1827

**Merced River, Yosemite Valley.** Albert Bierstadt,
American, 1830–1902. Oil on canvas, 1866.

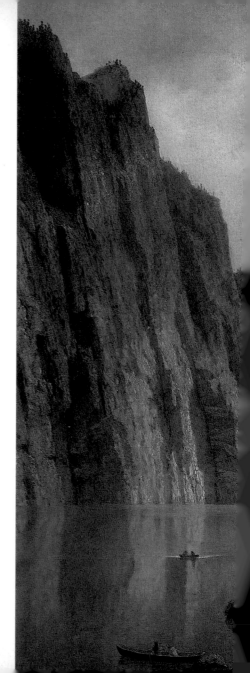

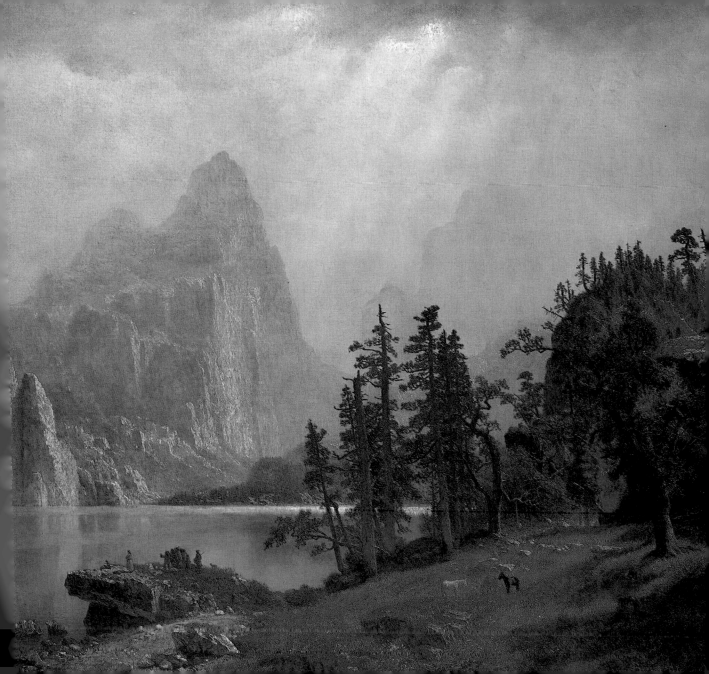

**Landscape.** Joseph Stella, American, 1877–1946.
Pastel and charcoal on paper, 1911.

## PIED BEAUTY

Glory be to God for dappled things—
    For skies of couple-colour as a brinded cow;
    For rose-moles all in stipple upon trout
        that swim;

Fresh-firecoal chestnut-falls; finches' wings;
    Landscape plotted and pieced—fold, fallow,
        and plough;
        And all trades, their gear and tackle and trim.

All things counter, original, spare, strange;
    Whatever is fickle, freckled (who knows
        how?)
        With swift, slow; sweet, sour; adazzle, dim;
He fathers-forth whose beauty is past change:
                Praise him.

GERARD MANLEY HOPKINS, English, 1844–1889

## TO NATURE

It may indeed be phantasy, when I
    Essay to draw from all created things
    Deep, heartfelt, inward joy that closely
        clings;
And trace in leaves and flowers that round me lie
Lessons of love and earnest piety.
    So let it be; and if the wide world rings
    In mock of this belief, it brings
Nor fear, nor grief, nor vain perplexity.
So will I build my altar in the fields,
    And the blue sky my fretted dome shall be,
And the sweet fragrance that the wild flower
  yields
    Shall be the incense I will yield to Thee,
Thee only God! and thou shalt not despise
Even me, the priest of this poor sacrifice.

SAMUEL TAYLOR COLERIDGE, English, 1772–1834

# IMAGINATION

There is a dish to hold the sea,
    A brazier to contain the sun,
A compass for the galaxy,
    A voice to wake the dead and done!

That minister of ministers,
    Imagination, gathers up
The undiscovered Universe,
    Like jewels in a jasper cup.

Its flame can mingle north and south;
    Its accent with the thunder strive;
The ruddy sentence of its mouth
    Can make the ancient dead alive.

The mart of power, the fount of will,
    The form and mold of every star,
The source and bound of good and ill,
    The key of all the things that are,

Imagination, new and strange
    In every age, can turn the year;
Can shift the poles and lightly change
    The mood of men, the world's career.

JOHN DAVIDSON, Scottish, 1857–1909

**The Titan's Goblet.** Thomas Cole, American, 1801–1848. Oil on canvas, 1833.

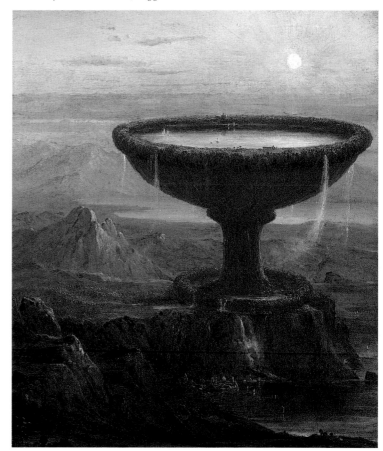

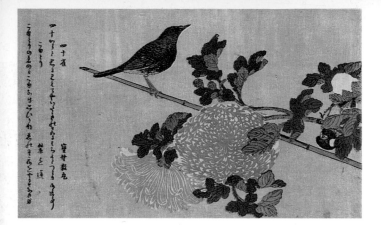

## TO MAKE THE PORTRAIT OF A BIRD

First paint a cage
with an open door
then paint
something pretty
something simple
something beautiful
something useful
for the bird
then place the canvas against a tree
in a garden
in a wood
or in a forest
hide behind the tree
without saying anything
without moving . . .
Sometimes the bird comes quickly
but it is possible for him to wait years
before he decides

Don't be discouraged
wait
wait if necessary for years
whether the bird comes fast or slow
has no
bearing
on the success of the picture
When the bird arrives
should he arrive
observe the most profound silence
wait until the bird enters the cage
and at that stage
shut the door gently with a putt of the brush
wipe out one by one all the bars
careful not to touch any of the bird's feathers
Then paint the tree
choosing the most beautiful branches
for the bird
paint too the green foliage and the freshness of
    the wind
the dust of the sun
the noise of insects in the grass in the summer
    heat
and then wait until the bird decides to sing
If the bird doesn't sing
it's a bad sign
a sign that the painting is bad
but if he sings it's a good sign
sign that you may sign
Then pull out very gently
one of the feathers of the bird
and write your name in a corner of the picture.

JACQUES PRÉVERT, French, 1900–1977

[ 62 ]

## THEIR LONELY BETTERS

As I listened from a beach-chair in the shade
To all the noises that my garden made,
It seemed to me only proper that words
Should be withheld from vegetables and birds.

A robin with no Christian name ran through
The Robin-Anthem which was all it knew,
And rustling flowers for some third party waited
To say which pairs, if any, should get mated.

No one of them was capable of lying,
There was not one which knew that it was dying
Or could have with a rhythm or a rhyme
Assumed responsibility for time.

Let them leave language to their lonely betters
Who count some days and long for certain letters;
We, too, make noises when we laugh or weep:
Words are for those with promises to keep.

   W. H. AUDEN, American (b. England), 1907–1973

**Japanese Robin and Chickadee
with Chrysanthemums.** Kitagawa Utamaro,
Japanese, 1753–1806. Colored woodblock print
from *Momochidori* (*Various Birds*), ca. 1790.

**Cottage Garden, Warwick, England.**
Edmund H. Garrett, American, 1853–1929.
Watercolor, gouache, and graphite on paper.

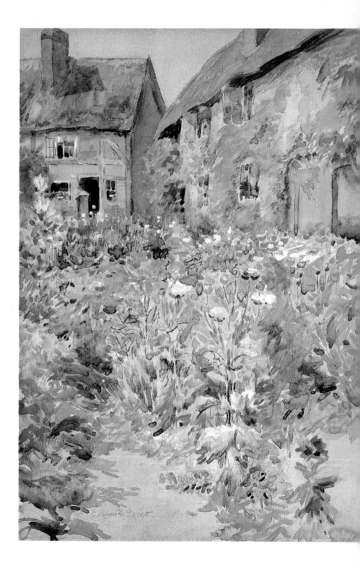

## ARS POETICA

To gaze at the river made of time and water
And recall that time itself is another river,
To know we cease to be, just like the river,
And that our faces pass away, just like the water.

To feel that waking is another sleep
That dreams it does not sleep and that death,
Which our flesh dreads, is that very death
Of every night, which we call sleep.

To see in the day or in the year a symbol
Of mankind's days and of his years,
To transform the outrage of the years
Into a music, a rumor and a symbol,

To see in death a sleep, and in the sunset
A sad gold, of such is Poetry
Immortal and a pauper. For Poetry
Returns like the dawn and the sunset.

At times in the afternoons a face
Looks at us from the depths of a mirror;
Art must be like that mirror
That reveals to us this face of ours.

They tell how Ulysses, glutted with wonders,
Wept with love to descry his Ithaca
Humble and green. Art is that Ithaca
Of green eternity, not of wonders.

It is also like an endless river
That passes and remains, a mirror for one same
Inconstant Heraclitus, who is the same
And another, like an endless river.

JORGE LUIS BORGES, Argentine, 1899–1986

## I WAS BORN UPON THY BANK, RIVER

I was born upon thy bank, river,
    My blood flows in thy stream,
And thou meanderest forever
    At the bottom of my dream.

HENRY DAVID THOREAU, American, 1817–1862

**Fur Traders Descending the Missouri.**
George Caleb Bingham, American, 1808–1879.
Oil on canvas, ca. 1845.

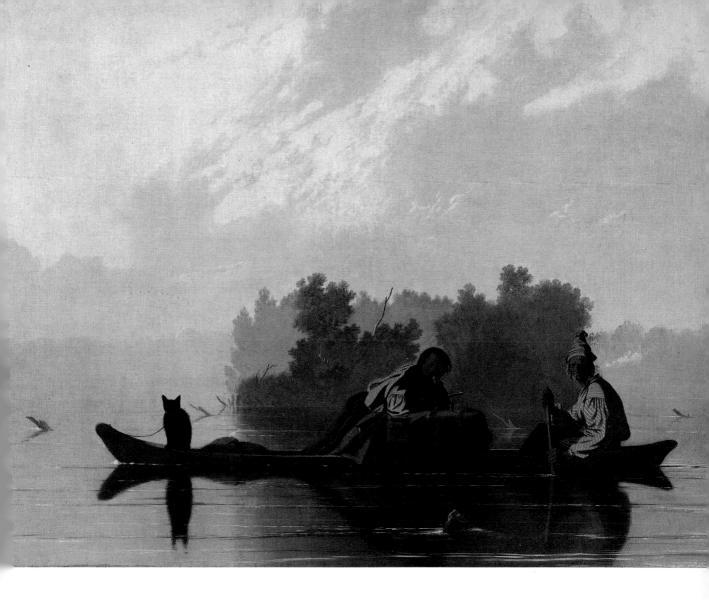

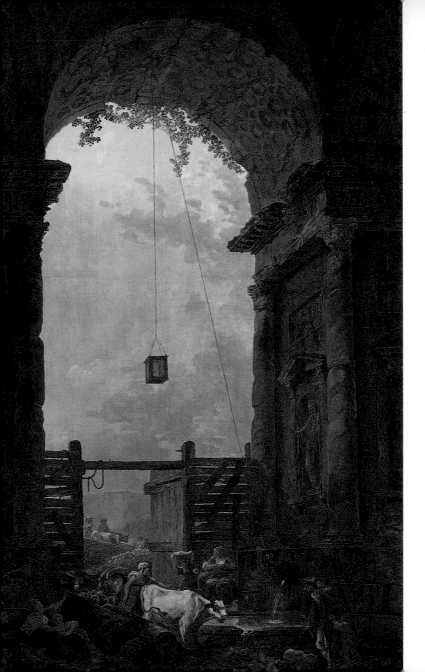

## LET EVENING COME

Let the light of late afternoon
shine through chinks in the barn, moving
up the bales as the sun moves down.

Let the cricket take up chafing
as a woman takes up her needles
and her yarn. Let evening come.

Let dew collect on the hoe abandoned
in long grass. Let the stars appear
and the moon disclose her silver horn.

Let the fox go back to its sandy den.
Let the wind die down. Let the shed
go black inside. Let evening come.

To the bottle in the ditch, to the scoop
in the oats, to air in the lung
let evening come.

Let it come, as it will, and don't
be afraid. God does not leave us
comfortless, so let evening come.

JANE KENYON, American, b. 1947

**The Return of the Cattle.** Hubert Robert,
French, 1733–1808. Oil on canvas.

**Gobelle's Mill at Optevoz.**
Charles-François Daubigny,
French, 1817–1878. Oil on
canvas.

## THE LAKE ISLE OF INNISFREE

I will arise and go now, and go to Innisfree,
And a small cabin build there, of clay and wattles
   made;
Nine bean rows will I have there, a hive for the
   honey bee,
And live alone in the bee-loud glade.

And I shall have some peace there, for peace
   comes dropping slow,
Dropping from the veils of the morning to where
   the cricket sings;
There midnight's all a glimmer, and noon a
   purple glow,
And evening full of the linnet's wings.

I will arise and go now, for always, night and day,
I hear lake-water lapping with low sounds by the
   shore;

While I stand on the roadway, or on the pavements
   gray,
I hear it in the deep heart's core.

WILLIAM BUTLER YEATS, Irish, 1865–1939

## DUSK IN THE COUNTRY

The riddle silently sees its image. It spins evening
among the motionless reeds.
There is a frailty no one notices
there, in the web of grass.

Silent cattle stare with green eyes.
They mosey in evening calm down to the water.
And the lake holds its immense spoon
up to all the mouths.

HARRY EDMUND MARTINSON, Swedish, 1904–1978

[ 67 ]

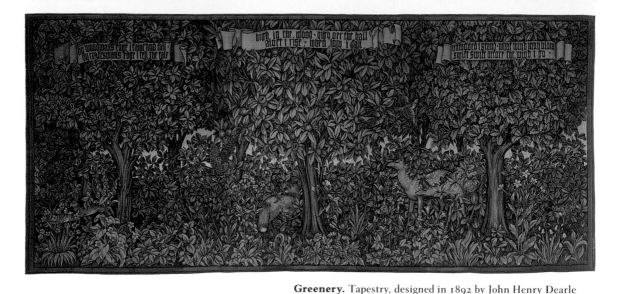

**Greenery.** Tapestry, designed in 1892 by John Henry Dearle (English, 1860–1932) for Morris and Company, Merton Abbey, England; woven in 1915. Wool and silk.

## COME INTO ANIMAL PRESENCE

Come into animal presence
No man is so guileless as
the serpent. The lonely white
rabbit on the roof is a star
twitching its ears at the rain.
The llama intricately
folding its hind legs to be seated
not disdains but mildly
disregards human approval.
What joy when the insouciant
armadillo glances at us and doesn't
quicken his trotting
across the track into the palm brush.

What is this joy? That no animal
falters, but knows what it must do?
That the snake has no blemish,
that the rabbit inspects his strange surroundings
in white star-silence? The llama
rests in dignity, the armadillo
has some intention to pursue in the palm-forest.
Those who were sacred have remained so,
holiness does not dissolve, it is a presence
of bronze, only the sight that saw it
faltered and turned from it.
An old joy returns in holy presence.

DENISE LEVERTOV, American, b. 1923

# WHEN HE HEARD THE OWLS
# AT MIDNIGHT

FROM THE SONG OF HIAWATHA

When he heard the owls at midnight,
Hooting, laughing in the forest,
"What is that?" he cried in terror;
"What is that?" he said, "Nokomis?"
And the good Nokomis answered:
"That is but the owl and owlet,
Talking in their native language,
Talking, scolding at each other."
Then the little Hiawatha
Learned of every bird its language,
Learned their names and all their secrets,
How they built their nests in Summer,
Where they hid themselves in Winter,
Talked with them whene'er he met them,
Called them "Hiawatha's Chickens."
Of all beasts he learned the language,
Learned their names and all their secrets,
How the beavers built their lodges,
Where the squirrels hid their acorns,
How the reindeer ran so swiftly,
Why the rabbit was so timid,
Talked with them whene'er he met them,
Called them "Hiawatha's Brothers."

HENRY WADSWORTH LONGFELLOW,
American, 1807–1882

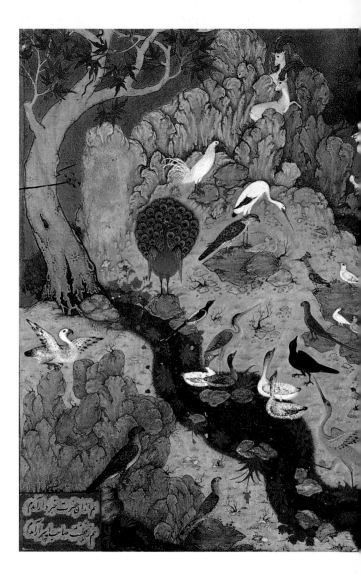

**The Concourse of the Birds.** From the *Mantiq al-Tayr* by Farid al-Din 'Attar. Signed by Habib Allah. Persian, period of Shah 'Abbas I, ca. 1600. Ink, colors, silver, and gold on paper.

**Tracery Light with Sun, Moon, and Stars.** Stained-glass panel from the choir of the castle chapel at Wienerneustadt, Lower Austria, ca. 1390.

## IS IT THE MORNING? IS IT THE LITTLE MORNING?

Is it morning? Is it the little morning
Just before dawn? How big the sun is!
Are those the birds? Their voices begin
Everywhere, whistling, piercing, and joyous
All over and in the air, speaking the words
Which are more than words, with mounting
    consciousness:
And everything begins to rise to the brightening
Of the slow light that ascends to the blaze's
    lightning!

DELMORE SCHWARTZ, American, 1913–1966

## THE EARLY MORNING

The moon on the one hand, the dawn on the
    other:
The moon is my sister, the dawn is my brother.
The moon on my left and the dawn on my right.
My brother, good morning: my sister, good night.

HILAIRE BELLOC, English, 1870–1953

**Sunrise on the Matterhorn.** Albert Bierstadt, American, 1830–1902. Oil on canvas, after 1875.

## BEAUTIFUL YOU RISE UPON THE HORIZON OF HEAVEN

FROM THE HYMN TO THE SUN

Beautiful you rise upon the horizon of heaven,
O living sun, you who have existed since the
    beginning of things . . .
The whole world is filled with your loveliness.
You are the god Ra, and you have brought every
    land under your yoke,
Bound them in with the force of your love.
You are far away, yet your beams flood down upon
    the earth.
You shine upon the faces of men,
And no one is able to fathom the mystery of your
    coming.
When you sleep in the West, beneath the horizon,
The earth is plunged in a shadow
That resembles the shadow of death . . .
But when the dawn comes you glitter on the
    horizon . . .
When day breaks, you chase away the black
    shades . . .
The Two Lands awake rejoicing,
Men rise up and stand upon their feet
With their arms stretched wide to hail your
    emergence!
The whole world then begins to go about its
    business.
The cattle champ their fodder contentedly;
Trees and plants open their leaves,
And birds forsake their nests,
Spreading their wings in adoration of your soul.

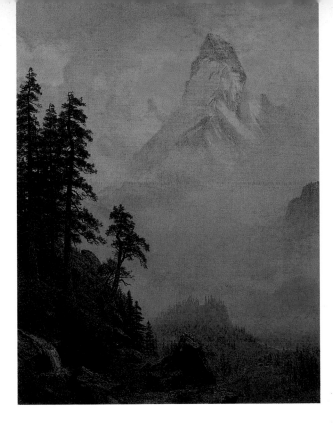

The young goats bound upwards,
And everything that flies and flaps its wings
Takes on a new lease of life when you smile upon
    it.
Boats are able to sail up and down the great river.
Your light illumines the highways and byways.
The very fish in the water cavort before you,
And your beams strike to the very depths of the
    ocean.

AKHENATON, Egyptian, 14th century B.C.

[ 71 ]

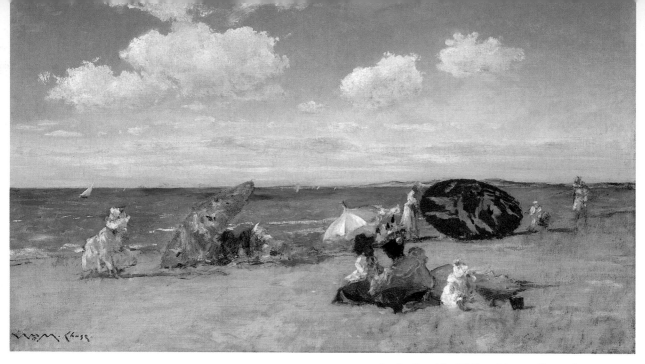

**At the Seaside.** William Merritt Chase, American,
1849–1916. Oil on canvas, ca. 1892.

## I REMEMBER THE SEA WHEN I WAS SIX . . .

I remember the sea when I was six
and ran on wetted sands
that were speckled with shells and the blowholes
  of clams
bedded secretly down in black muck—

I remember the sun, fishy airs, rotting piers
that reached far out into turquoise waters,

and ladies in white who sprinkled light laughter
from under their parasols. . . .

Where was it, that beach whose hot sand I
  troweled
day after day into my red tin pail?
It's only in dreams now I sense it, unreal,
at the end of an inner road no longer traveled.

FREDERICK MORGAN, American, b. 1922

[72]

## LEISURE

What is this life if, full of care,
We have no time to stand and stare?

No time to stand beneath the boughs
And stare as long as sheep or cows.

No time to see, when woods we pass,
Where squirrels hide their nuts in grass.

No time to see, in broad daylight,
Streams full of stars, like skies at night.

No time to turn at Beauty's glance,
And watch her feet, how they can dance.

No time to wait till her mouth can
Enrich that smile her eyes began.

A poor life this if, full of care,
We have no time to stand and stare.

William H. Davies, English, 1870–1940

## AND THE DAYS ARE NOT FULL ENOUGH

And the days are not full enough
And the nights are not full enough
And life slips by like a field mouse
            Not shaking the grass.

Ezra Pound, American, 1885–1972

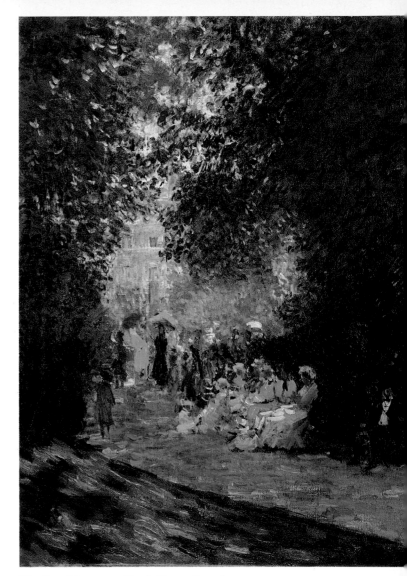

**The Parc Monceau.** Claude Monet, French, 1840–1926. Oil on canvas, 1878.

Cat and Yellow Butterfly. Hsü Pei-hung, Chinese, 1895–1953. Hanging scroll; ink and color on paper.

And you go off, old roisterer,
Away into the dark?

I think you play at leopards and panthers;
I think you wander on to foreign properties;
But on winter mornings you are a lost orphan
Pitifully wailing underneath our windows;
And in summer, by the open doorway,
You come in pad, pad, lazily to breakfast,
Plumy tail waving, with a fine swagger,
Like a drum-major, or a parish beadle,
Or a rich rajah, or the Grand Mogul.

MARY URSULA BETHELL, New Zealand, 1874–1945

## THE EARTHWORM

Who really respects the earthworm,
the farmworker far under the grass in the soil.
He keeps the earth always changing
He works entirely full of soil,
speechless with soil, and blind.

He is the underneath farmer, the underground
    one,
where the fields are getting on their harvest
    clothes.
Who really respects him,
this deep and calm earth-worker,
this deathless, gray, tiny farmer in the planet's
    soil.

HARRY EDMUND MARTINSON, Swedish, 1904–1978

## GARDEN LION

O Michael, you are at once the enemy
And the chief ornament of our garden,
Scrambling up rose-posts, nibbling at nepeta,
Making your lair where tender plants should
    flourish,
Or proudly couchant on a sun-warmed stone.

What do you do all night there,
When we seek our soft beds,

[74]

## ADO

It grows too fast! I cannot keep pace with it!
While I mow the front lawns, the drying green
    becomes impossible;
While I weed the east path, from the west path
    spring dandelions;
What time I sort the borders, the orchard
    escapes me.

And then the interruptions! the interlopers!

While I clap my hands against the blackbird,
Michael, our cat, is rolling on a seedling;
While I chase Michael, a young rabbit is eyeing
    the lettuces.

And oh the orgies, to think of the orgies
When I am not present to preside over this
    microcosm!

         MARY URSULA BETHELL, New Zealand, 1874–1945

**King's Cookham Rise.** Stanley Spencer, British, 1891–1959. Oil on canvas, 1947.

**Wheatfields.** Jacob van Ruisdael, Dutch, 1628/29–1682. Oil on canvas.

## IN THE FIELDS

Lord, when I look at lovely things which pass,
　　Under old trees the shadows of young leaves
Dancing to please the wind along the grass,
　　Or the gold stillness of the August sun on
　　　the August sheaves;
Can I believe there is a heavenlier world than
　this?

And if there is
Will the strange heart of any everlasting thing
　　Bring me these dreams that take my breath
　　　away?
They come at evening with the home-flying rooks
　and the scent of hay,
　　Over the fields. They come in Spring.

CHARLOTTE MEW, English, 1869–1928

## ALLEGORY

As a youth, I picked flowers from the meadow
And carefully brought the bouquet back home,
But, warmed by my hand, the flowers
Bent their heads to the ground.
I placed them in a glass of fresh water
And what a miracle it was!
The little heads lifted themselves back up,
The leafy stems flowered green,
Altogether, as healthy as though
They still stood on their mother ground.

For me it was like hearing my song
Sung beautifully in a foreign tongue.

JOHANN WOLFGANG VON GOETHE,
German, 1749–1832

**Pansies on a Table.** Henri Matisse, French, 1869–1954.
Oil on paper, mounted on wood, ca. 1918–19.

## TO MAKE A PRAIRIE

To make a prairie it takes a clover
    and one bee,—
One clover, and a bee,
And revery.
The revery alone will do
If bees are few.

EMILY DICKINSON, American, 1830–1886

## UNEXPECTED SUNFLOWERS

O radiant you sunflowers abound
on Thirtieth Street and Tenth Avenue
spectacular where no one would expect you,
but *I* know, my birthday comes around,
to look there for you lush on barren ground
with hairy leaves. The buds are cut like beautiful
   emeralds.

        Let me pick a few

of these wildflowers native among abandoned
trucks and empty freightcars and warehouses
and bring them home and put them in a vase.

I cannot look away. Their symmetry
is Mediterranean and their energy
Northern, and each has the majesty
of the sun alone in the blue sky.

      PAUL GOODMAN, American, 1911–1972

**Sunflowers.** Vincent van Gogh, Dutch, 1853–1890. Oil on canvas, 1887.

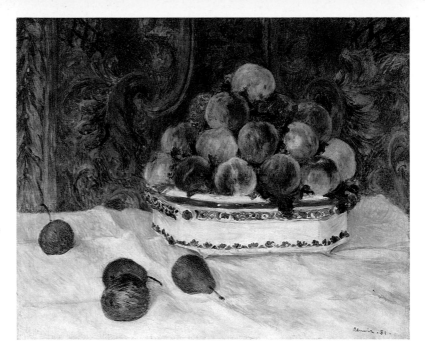

**Still Life with Peaches.**
Pierre-Auguste Renoir, French,
1841–1919. Oil on canvas, 1881.

## FROM BLOSSOMS

From blossoms comes
this brown paper bag of peaches
we bought from the boy
at the bend in the road where we turned toward
signs painted *Peaches*.

From laden boughs, from hands,
from sweet fellowship in the bins,
comes nectar at the roadside, succulent
peaches we devour, dusty skin and all,
comes the familiar dust of summer, dust we eat.

O, to take what we love inside,

to carry within us an orchard, to eat
not only the skin, but the shade,
not only the sugar, but the days, to hold
the fruit in our hands, adore it, then bite into
the round jubilance of peach.

There are days we live
as if death were nowhere
in the background; from joy
to joy to joy, from wing to wing,
from blossom to blossom to
impossible blossom, to sweet impossible blossom.

LI-YOUNG LEE, American, b. 1957

[79]

## TOO MUCH HEAT, TOO MUCH WORK

It's the fourteenth of August, and I'm too hot
To endure food, or bed. Steam and the fear of
  scorpions
Keep me awake. I'm told the heat won't fade with
  Autumn.

Swarms of flies arrive. I'm roped into my clothes.

In another moment I'll scream down the office
As the paper mountains rise higher on my desk.

O those real mountains to the south of here!
I gaze at the ravines kept cool by pines.
If I could walk on ice, with my feet bare!

    Tu Fu, Chinese, 712–770

## HEAT

O wind, rend open the heat,
cut apart the heat,
rend it to tatters.

Fruit cannot drop
through this thick air—
fruit cannot fall into heat
that presses up and blunts
the points of pears
and rounds the grapes.

Cut the heat—
plough through it,
turning it on either side
of your path.

    H. D. (Hilda Doolittle),
        American, 1886–1961

## THE STORM AND THE CALM

I saw the rosy sun's calm light
become cloudy, its cheerful face
abruptly vanish and on all sides
the sky darken with a terrible darkness.

The savage south wind blasted furiously;
with rising rage, the fierce storm roared,
and on the shoulders of Atlas
tall Olympus shook with a thunderous
    warning,

but then I saw the black cloud divide
and dissolve in water, the clear day
return with its first glad light,

and a new splendor adorn the sky.
Watching, I said: "Who knows? The same
kind of change may yet transform my life."

JUAN DE ARGUIJO, Spanish, 1565–1623

**View of Toledo.** El Greco (Domenicos Theotocopoulos),
Spanish (b. Crete), 1541–1614. Oil on canvas.

**Related to Downtown New York, Movement No. 2
(The Black Sun).** John Marin, American, 1870–1953.
Watercolor and charcoal on paper, 1926.

[ 81 ]

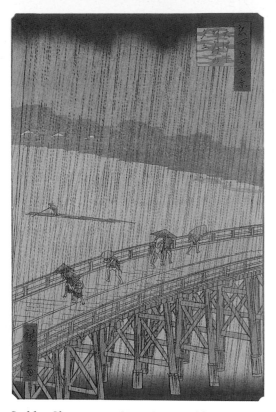

**Sudden Shower over New Great Bridge and Atake.** Utagawa Hiroshige, Japanese, 1797–1858. Woodblock print in colors from the series *One Hundred Famous Views of Edo*, 1857.

## I BRING FRESH SHOWERS FOR THE THIRSTING FLOWERS

FROM THE CLOUD

I bring fresh showers for the thirsting flowers,
    From the seas and the streams;
I bear light shade for the leaves when laid
    In their noonday dreams.
From my wings are shaken the dews that waken
    The sweet buds every one,
When rocked to rest on their mother's breast,
    As she dances about the sun.
I wield the flail of the lashing hail,
    And whiten the green plains under,
And then again I dissolve it in rain,
    And laugh as I pass in thunder.

———

I am the daughter of Earth and Water,
    And the nursling of the Sky;
I pass through the pores of the ocean and shores;
    I change, but I cannot die.
For after the rain when with never a stain
    The pavilion of Heaven is bare,
And the winds and sunbeams with their convex gleams
    Build up the blue dome of air,
I silently laugh at my own cenotaph,
    And out of the caverns of rain,
Like a child from the womb, like a ghost from the tomb,
    I arise and unbuild it again.

PERCY BYSSHE SHELLEY, English, 1792–1822

[ 82 ]

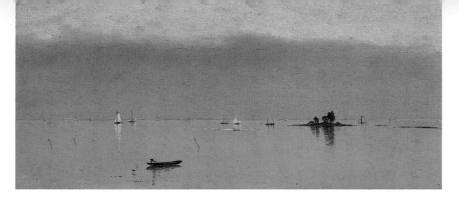

**Passing Away of the Storm.**
John Frederick Kensett, American,
1816–1872. Oil on canvas, 1872.

## THE WIND TOOK UP
## THE NORTHERN THINGS

The Wind took up the Northern Things
And piled them in the south—
Then gave the East unto the West
And opening his mouth

The four Divisions of the Earth
Did make as to devour
While everything to corners slunk
Behind the awful power—

The Wind—unto his Chambers went
And nature ventured out—
Her subjects scattered into place
Her systems ranged about

Again the smoke from Dwellings rose
The Day abroad was heard—
How intimate, a Tempest past
The Transport of the Bird—

    EMILY DICKINSON, American, 1830–1886

## AFTER CLOUDS AND RAIN

It rained all day. Now a single bird
sings madly in the forest.

I like to think of your body wet
and smelling of bubblebath.

The little bird chuckles, laughs,
then waits a few moments in silence.

You comb out your soaking hair.
Raindrops trickle through leaves.

    SAM HAMILL, American, b. 1942

**Woman Combing Her Hair.**
Edgar Degas, French, 1834–1917.
Pastel on paper, ca. 1888–90.

[83]

## PEACE IN THIS GREEN FIELD

**Banks of the River Marne.**
Henri Cartier-Bresson, French,
b. 1908. Gelatin silver print, 1938.

Peace in this green field.

Bird any damn kind—
They're all good! *My God!*
Grass flowers the wind—
What more do you want!

Do you know something—
I think it's beautiful!
Makes you feel great
Just to be alive!

*My God!* What more is there!
Piece of grass, huh?
All warmed by the sun—
Somebody pretty alongside you!

Boy! that's it, you know—
Maybe a glass of beer, huh?
Your arm around her—
*My God!* You can say that again!

KENNETH PATCHEN, American, 1911–1972

## THE SUNFLOWER

Bring me the sunflower so that I can transplant it
In the salt-scorched soil of my yard,
And let it spend its days showing the mirroring
    blues
Of the sky its ardent yellow face.

Dark things long for light;
They surrender their shapes in a flow
Of color: color flows into music. To vanish
Is thus the fortune of fortunes.

You must bring me the plant that leads
Where pale transparencies rise
And life evaporates as an essence;
Bring me the sunflower, madly in love with light.

    EUGENIO MONTALE, Italian, 1896–1981

**Large Sunflowers I.** Emil Nolde, German, 1867–1956. Oil on wood, 1928.

## IT IS PEACEFUL COMING HOME ACROSS THE MEADOW

It is peaceful coming home across the meadow,
the flowers are continuous as I come.
My bounding beagle somewhere in the hay
is invisible, except her flapping ears
and the white curl of her happy tail
moving through the swaying sea.
The yellow flowers are closing in the evening.
I am not lonely for my only world
is softly singing to me as I come.
They who know me as a bitter critic
who is impractical to serve his country
know me poorly; I am freeborn and pleased
with this world that I have inherited.
And ever my little dog is looking back
with her gleaming eye, and waits if I am coming.

    PAUL GOODMAN, American, 1911–1972

## WHAT WONDROUS LIFE IS THIS I LEAD!

FROM THE GARDEN

What wondrous life is this I lead!
Ripe apples drop about my head;
The luscious clusters of the vine
Upon my mouth do crush their wine;
The nectarine and curious peach
Into my hands themselves do reach;
Stumbling on melons, as I pass,
Ensnared with flowers, I fall on grass.

Meanwhile the mind, from pleasure less,
Withdraws into its happiness;
The mind, that ocean where each kind
Does straight its own resemblance find;
Yet it creates, transcending these,
Far other worlds and other seas,
Annihilating all that's made
To a green thought in a green shade.

Here at the fountain's sliding foot
Or at some fruit-tree's mossy root,
Casting the body's vest aside
My soul into the boughs does glide:
There, like a bird, it sits and sings,
Then whets and claps its silver wings,
And, till prepared for longer flight,
Waves in its plumes the various light.

ANDREW MARVELL, English, 1621–1678

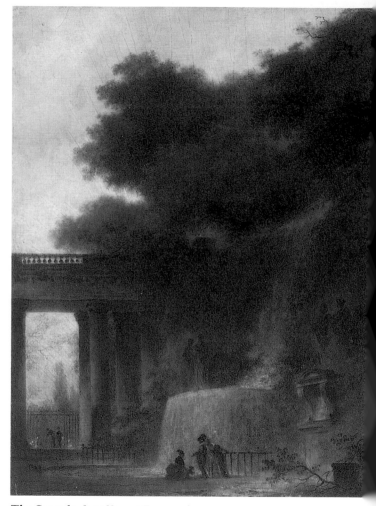

**The Cascade.** Jean Honoré Fragonard,
French, 1732–1806. Oil on wood.

## THEME

The golden eve is all astir,
And tides of sunset flood on us
—Incredible, miraculous—
We look with adoration on
Beauty coming, beauty gone,
That waits not any looking on.

Thoughts will bubble up, and break,
Spilling a sea, a limpid lake,
Into the soul; and, as they go
—Lightning visitors! we know
A lattice opened, and the mind
Poised for all that is behind
The lattice, and the poising mind.

Could the memory but hold!
—All the sunsets, flushed with gold,
Are streaming in it!

All the store
Of all that ever was before
Is teeming in it!

All the wit
Of holy living, holy writ,

Waiting till we remember it,
Is dreaming in it!

    JAMES STEPHENS, Irish, 1882–1950

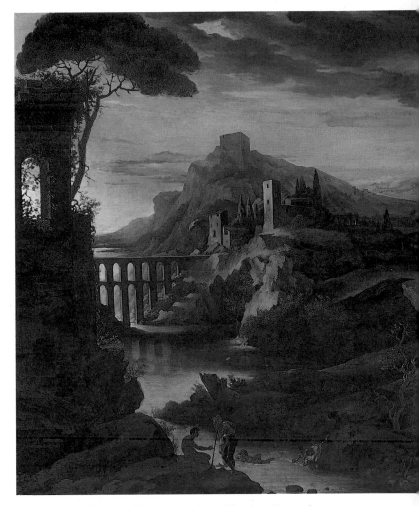

**Evening: Landscape with an Aqueduct.** Théodore Gericault,
French, 1791–1824. Oil on canvas, 1818.

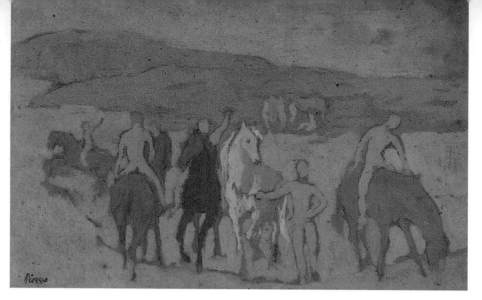

**The Watering Place.** Pablo Picasso, Spanish, 1881–1973. Gouache on pulp board, 1906.

## A BLESSING

Just off the highway to Rochester, Minnesota,
Twilight bounds softly forth on the grass.
And the eyes of those two Indian ponies
Darken with kindness.
They have come gladly out of the willows
To welcome my friend and me.
We step over the barbed wire into the pasture
Where they have been grazing all day, alone.
They ripple tensely, they can hardly contain
    their happiness
That we have come.
They bow shyly as wet swans. They love each
    other.
There is no loneliness like theirs.
At home once more,
They begin munching young tufts of spring in
    the darkness.
I would like to hold the slenderer one in my
    arms,
For she has walked over to me
And nuzzled my left hand.
She is black and white,
Her mane falls wild on her forehead,
And the light breeze moves me to caress her long
    ear
That is delicate as the skin over a girl's wrist.
Suddenly I realize
That if I stepped out of my body I would break
Into blossom.

JAMES WRIGHT, American, 1927–1980

[ 88 ]

## THE GRAVID MARES

FROM THE GEORGICS

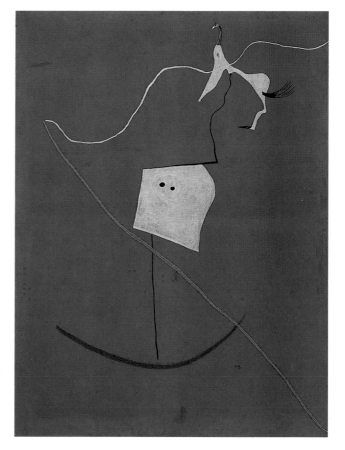

        The gravid mares
graze out their months in gentle stateliness,
freed from all human burdens by their own,
kept close in care, pastured in shady fields
where quiet rivers lap the quieter moss
that lines their banks.

        The mares go out at dawn
and again at dusk (avoiding the gadflies' noon);
you see them taking shape in the morning mist

or burnished by the golden light of sunset . . .
Tricks of the light?

        But we must believe our eyes
even at miracles. Huge and yet delicate,
they stalk their time, the creatures of a dream
(The gods'? Ours? Their own?).
                And wake.
                  And foal.
The marvel of it fades—all marvels do—
and feeling our way, our confidence again,
we lapse into routines, as the gods do, too,
of the business of life.

    VIRGIL, Roman, 70–19 B.C.

**The Circus Horse.** Joan Miró, Spanish,
1893–1983. Tempera on canvas, 1927.

## THIS LUNAR BEAUTY

This lunar beauty
Has no history,
Is complete and early;
If beauty later
Bear any feature,
It had a lover
And is another.

This like a dream
Keeps other time,
And daytime is
The loss of this;
For time is inches
And the heart's changes,
Where ghost has haunted
Lost and wanted.

But this was never
A ghost's endeavour
Nor, finished this,
Was ghost at ease;
And till it pass
Love shall not near
The sweetness here,
Nor sorrow take
His endless look.

W. H. AUDEN, American
(b. England), 1907–1973

## THE NIGHT-WIND OF AUGUST

The night-wind of August
Is like an old mother to me.
It comforts me.
I rest in it,
As one would rest,
If one could,
Once again—
It moves about, quietly
And attentively.
Its old hands touch me.
Its breath touches me.
But sometimes its breath is a little cold,
Just a little,
And I know
That it is only the night-wind.

WALLACE STEVENS, American, 1879–1955

## FRESH FROM THE VOID

Fresh from the void
The moon
On the waves of the sea.

MASAOKA SHIKI, Japanese, 1867–1902

**Moonlight, Wood Island Light.** Winslow Homer,
American, 1836–1910. Oil on canvas, 1894.

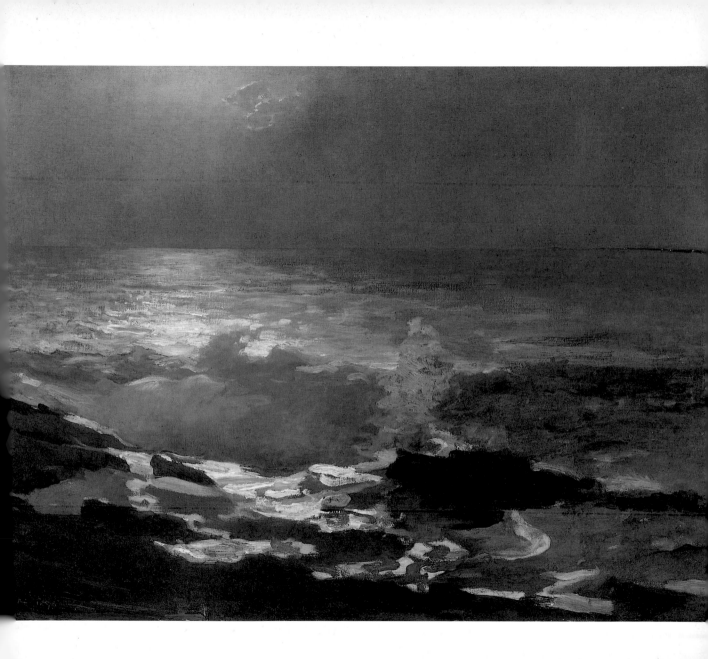

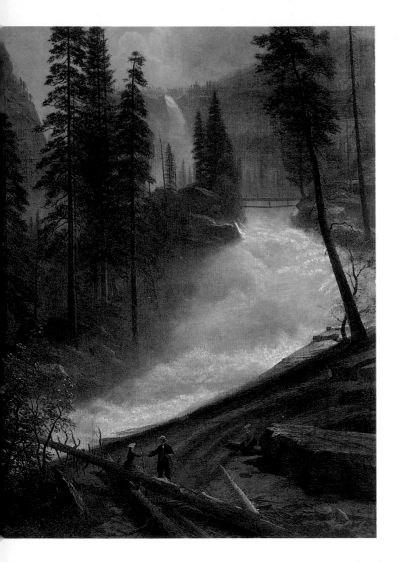

## FOR ALL

Ah to be alive
    on a mid-September morn
    fording a stream
    barefoot, pants rolled up,
    holding boots, pack on,
    sunshine, ice in the shallows,
    northern rockies.

Rustle and shimmer of icy creek waters
stones turn underfoot, small and hard as toes
    cold nose dripping
    singing inside
    creek music, heart music,
    smell of sun on gravel.

    I pledge allegiance

I pledge allegiance to the soil
    of Turtle Island,
and to the beings who thereon dwell

    one ecosystem
    in diversity
    under the sun
With joyful interpenetration for all.

    GARY SNYDER, American, b. 1930

**Nevada Falls, Yosemite.** Albert Bierstadt,
American, 1830–1902. Oil on canvas, ca. 1872.

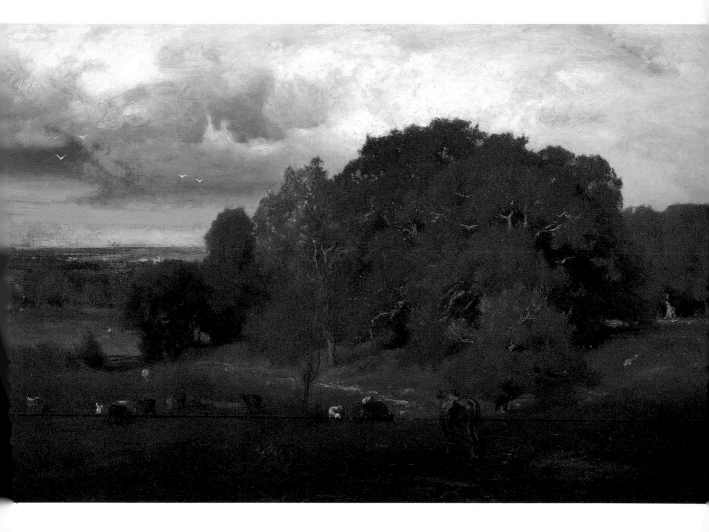

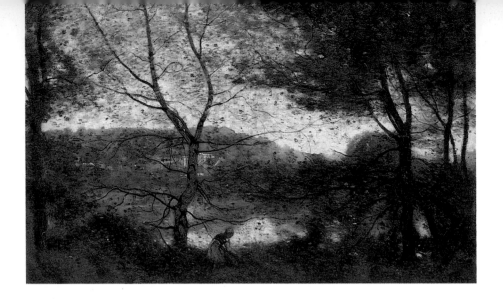

## FALL, LEAVES, FALL

Fall, leaves, fall; die, flowers, away;
Lengthen night and shorten day;
Every leaf speaks bliss to me
Fluttering from the autumn tree.
I shall smile when wreaths of snow
Blossom where the rose should grow;
I shall sing when night's decay
Ushers in a drearier day.

    EMILY BRONTË, English, 1818–1848

**Ville d'Avray.** Camille Corot, French,
1796–1875. Oil on canvas.

## NOW

The longed-for summer goes;
Dwindles away
To its last rose,
Its narrowest day.

No heaven-sweet air but must die;
Softlier float,
Breathe lingeringly
Its final note.

Oh, what dull truths to tell!
*Now* is the all-sufficing all
Wherein to love the lovely well,
Whate'er befall.

    WALTER DE LA MARE, English,
              1873–1956

**Saltillo Mansion.** Edward Hopper, American, 1882–1967. Watercolor on paper, 1943.

## FIRST MOMENT OF AUTUMN RECOGNIZED

Hills haven the last cloud. However white. From
    brightest blue
Spills glitter of afternoon, more champagne than
    ever
Summer. Bubble and sparkle burst in
Tang, taste, tangle, tingle, delicious
On tongue of spirit, joyful in eye-beam. We know
This to be no mere moment, however brief,
However blessèd, for
Moment means time, and this is no time,
Only the dream, untimed, between
Season and season. Let the leaf, gold, of birch,

Of beech, forever hang, not vegetable matter
    mortal, but
In no whatsoever breath of
Air. No—embedded in
Perfection of crystal, purer
Than air. You, embedded too in
Crystal, stand, your being perfected
At last, in the instant itself which is unbreathing.

Can you feel breath brush your damp
Lips? How can you know?

    Robert Penn Warren, American, 1905–1989

## AUTUMN

Sky full of autumn
earth like crystal
news arrives from a long way off following one
    wild goose.
The fragrance gone from the ten foot lotus
by the Heavenly Well.
Beech leaves
fall through the night onto the cold river,
fireflies drift by the bamboo fence.
Summer clothes are too thin.
Suddenly the distant flute stops
and I stand a long time waiting.
Where is Paradise
so that I can mount the phoenix and fly there?

    NGO CHI LAN, Vietnamese, 15th century

**Asakusa Rice Fields and Torinomachi Festival.**
Utagawa Hiroshige, Japanese, 1797–1858. Woodblock
print in colors from the series *One Hundred Famous
Views of Edo*, 1857.

## THE VALLEY WIND

Living in retirement beyond the World,
Silently enjoying isolation,
I pull the rope of my door tighter
And stuff my window with roots and ferns.
My spirit is tuned to the Spring-season:
At the fall of the year there is autumn in my
    heart.
Thus imitating cosmic changes
My cottage becomes a Universe.

    LU YÜN, Chinese, 4th century

## TWILIGHT

Looking across
The water we are
Startled by a star—
It is not dark yet
The sun has just set

Looking across
The water we are
Alone as that star
That startled us,
And as far

SAMUEL MENASHE,
American, b. 1925

Beach Scene. James Hamilton, American, 1819–1878.
Watercolor and gouache on off-white paper, ca. 1865.

## AUTUMN EVENING

Though the little clouds ran southward still, the
    quiet autumnal
Cool of the late September evening
Seemed promising rain, rain, the change of the
    year, the angel
Of the sad forest. A heron flew over
With that remote ridiculous cry, "Quawk," the
    cry
That seems to make silence more silent. A dozen
Flops of the wing, a drooping glide, at the end of
    the glide
The cry, and a dozen flops of the wing.
I watched him pass on the autumn-colored sky;
    beyond him
Jupiter shone for evening star.
The sea's voice worked into my mood, I thought
    "No matter
What happens to men . . . the world's well made
    though."

ROBINSON JEFFERS, American, 1887–1962

[ 97 ]

**Young Girl Peeling Apples.** Nicolaes Maes,
Dutch, 1634–1693. Oil on wood.

## TO AUTUMN

Season of mists and mellow fruitfulness,
   Close bosom-friend of the maturing sun;
Conspiring with him how to load and bless
   With fruit the vines that round the thatch-
      eaves run;
To bend with apples the moss'd cottage-trees,
   And fill all fruit with ripeness to the core;
     To swell the gourd, and plump the hazel
      shells
With a sweet kernel; to set budding more,
   And still more, later flowers for the bees,
   Until they think warm days will never cease;
     For summer has o'erbrimm'd their clammy
      cells.

Who hath not seen thee oft amid thy store?
   Sometimes whoever seeks abroad may find
Thee sitting careless on a granary floor,
   Thy hair soft-lifted by the winnowing wind;
Or on a half-reap'd furrow sound asleep,
   Drows'd with the fume of poppies, while thy
   hook
     Spares the next swath and all its twinéd
      flowers;
And sometimes like a gleaner thou dost keep
   Steady thy laden head across a brook;
   Or by a cider-press, with patient look,
     Thou watchest the last oozings, hours by
      hours.

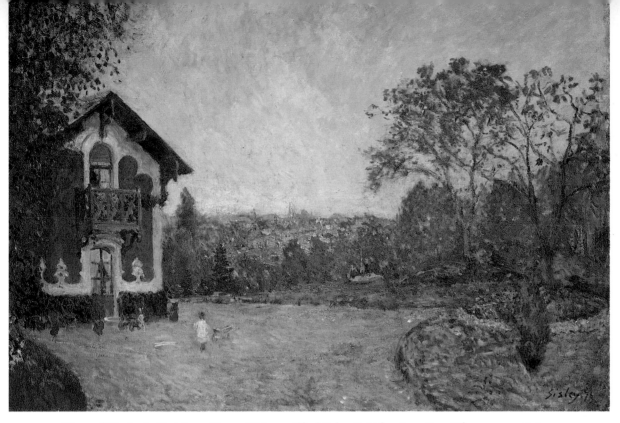

**View of Marly-le-Roi from Coeur-Volant.** Alfred Sisley, British, 1839–1899. Oil on canvas, 1876.

Where are the songs of Spring? Aye, where are
    they?
    Think not of them,—thou hast thy music too,
While barréd clouds bloom the soft-dying day
    And touch the stubble-plains with rosy hue;
Then in a wailful choir the small gnats mourn

Among the river sallows, borne aloft
    Or sinking as the light wind lives or dies;
And full-grown lambs loud bleat from hilly bourn;
    Hedge-crickets sing, and now with treble soft
The redbreast whistles from a garden-croft,
    And gathering swallows twitter in the skies.

JOHN KEATS, English, 1795–1821

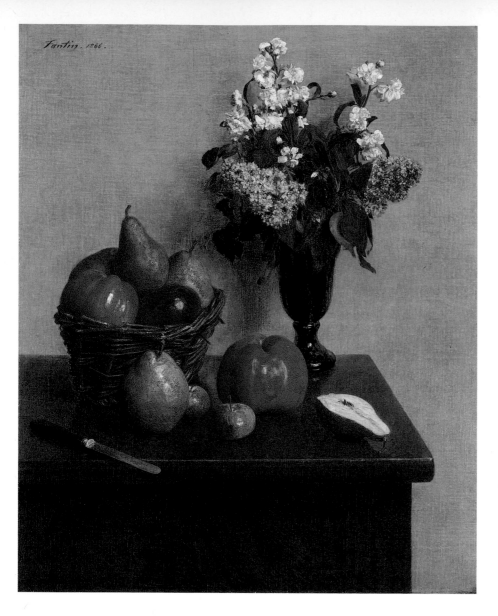

## OCTOBER

Books litter the bed,
leaves the lawn. It
lightly rains. Fall has
come: unpatterned, in
the shedding leaves.

The maples ripen. Apples
come home crisp in bags.
This pear tastes good.
It rains lightly on the
random leaf patterns.

The nimbus is spread
above our island. Rain
lightly patters on un-
shed leaves. The books
of fall litter the bed.

JAMES SCHUYLER, American,
1923–1991

**Still Life with Flowers and
Fruit.** Henri Fantin-Latour,
French, 1836–1904. Oil on
canvas, 1866.

## AUTUMN DAY

Lord: it is time. The huge summer has gone by.
Now overlap the sundials with your shadows,
and on the meadows let the wind go free.

Command the fruits to swell on tree and vine;
grant them a few more warm transparent days,
urge them on to fulfillment then, and press
the final sweetness into the heavy wine.

Whoever has no house now, will never have one.
Whoever is alone will stay alone,
will sit, read, write long letters through the
    evening,
and wander on the boulevards, up and down,
restlessly, while the dry leaves are blowing.

RAINER MARIA RILKE, Austrian, 1875–1926

**Autumn Ivy.** Ogata Kenzan, Japanese, 1663–1743.
Hanging scroll; color and ink on paper.

## THE DAY OF CHUNG YANG

(October 1929)

How fleeting is our youth,
Though heaven stays forever young!
Year after year
The day of Chung Yang returns.
On this day of Chung Yang,
The yellow flowers smell extraordinarily sweet,
The yellow flowers which grow on the old
    battlefields.

Once again the autumn wind is blowing briskly
    across the land.
How different it is from the warm breath of
    spring!
Yet the autumn vigor surpasses even the springtime
    splendor,
For from here to where the river meets the sky,
Lies a great empty expanse,
A great empty expanse which is ablaze with
    leaves in flame.

MAO TSE-TUNG, Chinese, 1893–1976

## THE TABLES TURNED

Up! up! my Friend, and quit your books:
Or surely you'll grow double:
Up! up! my Friend, and clear your looks;
Why all this toil and trouble?

The sun, above the mountain's head,
A freshening lustre mellow
Through all the long green fields has spread,
His first sweet evening yellow.

Books! 'tis a dull and endless strife:
Come, hear the woodland linnet,
How sweet his music! on my life,
There's more of wisdom in it.

And hark! how blithe the throstle sings!
He, too, is no mean preacher:
Come forth into the light of things,
Let Nature be your Teacher.

She has a world of ready wealth,
Our minds and hearts to bless—
Spontaneous wisdom breathed by health,
Truth breathed by cheerfulness.

One impulse from a vernal wood
May teach you more of man,
Of moral evil and of good,
Than all the sages can.

Sweet is the lore which Nature brings;
Our meddling intellect
Mis-shapes the beauteous forms of things:—
We murder to dissect.

Enough of Science and of Art;
Close up those barren leaves;
Come forth, and bring with you a heart
That watches and receives.

WILLIAM WORDSWORTH, English, 1770–1850

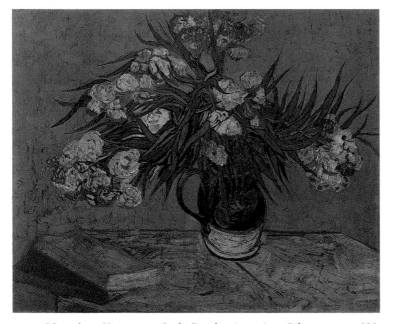

**Oleanders.** Vincent van Gogh, Dutch, 1853–1890. Oil on canvas, 1888.

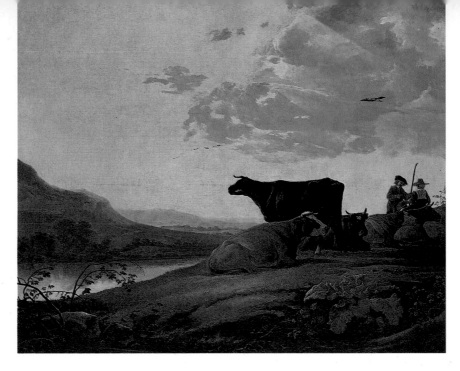

**Young Herdsmen with Cows.**
Aelbert Cuyp, Dutch, 1620–1691.
Oil on canvas.

## SOLITUDE

Happy the man whose wish and care
A few paternal acres bound,
Content to breathe his native air
    In his own ground.

Whose herds with milk, whose fields with bread,
Whose flocks supply him with attire;
Whose trees in summer yield him shade,
    In winter fire.

Blest, who can unconcern'dly find
Hours, days, and years slide soft away

In health of body, peace of mind;
    Quiet by day,

Sound sleep by night; study and ease
Together mixed; sweet recreation;
And innocence, which most does please
    With meditation.

Thus let me live, unseen, unknown;
Thus unlamented let me die;
Steal from the world, and not a stone
    Tell where I lie.

ALEXANDER POPE, English, 1688–1744

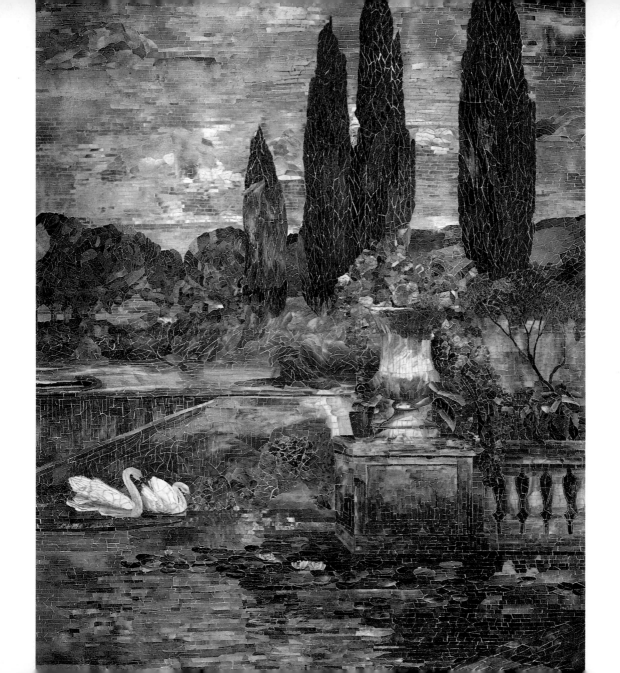

## THE WILD SWANS AT COOLE

The trees are in their autumn beauty,
The woodland paths are dry,
Under the October twilight the water
Mirrors a still sky;
Upon the brimming water among the stones
Are nine-and-fifty swans.

The nineteenth autumn has come upon me
Since I first made my count;
I saw, before I had well finished,
All suddenly mount
And scatter wheeling in great broken rings
Upon their clamorous wings.

I have looked upon those brilliant creatures,
And now my heart is sore.
All's changed since I, hearing at twilight,
The first time on this shore,
The bell-beat of their wings above my head,
Trod with a lighter tread.

Unwearied still, lover by lover,
They paddle in the cold
Companionable streams or climb the air;
Their hearts have not grown old;
Passion or conquest, wander where they will,
Attend upon them still.

But now they drift on the still water,
Mysterious, beautiful;
Among what rushes will they build,
By what lake's edge or pool
Delight men's eyes when I awake some day
To find they have flown away?

WILLIAM BUTLER YEATS, Irish, 1865–1939

## HALF OF LIFE

With yellow pears and full
Of wild roses, the land
Reaches down to the lake,
You graceful swans,
And drunk with kisses,
You dunk your heads
In the sacredly sobering water.

Where, alas, when winter comes,
Will I take the flowers, and where
The sunshine
And shadows of earth?
The walls stand
Speechless and cold, the flags
Rattle and clank in the wind.

FRIEDRICH HÖLDERLIN, German, 1770–1843

Landscape. Tiffany Studios, New York.
Glass mosaic, ca. 1905–15.

## IF THE OWL CALLS AGAIN

at dusk
from the island in the river,
and it's not too cold,

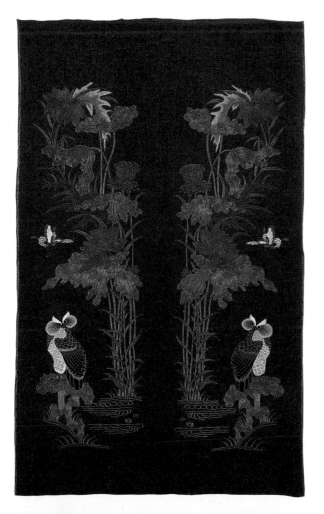

I'll wait for the moon
to rise,
then take wing and glide
to meet him.

We will not speak,
but hooded against the frost
soar above
the alder flats, searching
with tawny eyes.

And then we'll sit
in the shadowy spruce and
pick the bones
of careless mice,

while the long moon drifts
toward Asia
and the river mutters
in its icy bed.

And when morning climbs
the limbs
we'll part without a sound,

fulfilled, floating
homeward as
the cold world awakens.

JOHN HAINES, American, b. 1924

**Owl Beneath a Lotus Flower.**
Satin panel couched in gold and
embroidered with colored silks.
Chinese, Ch'ing dynasty, 19th century.

## EMPTY WATER

I miss the toad,
who came all summer
to the limestone
water basin
under the Christmasberry tree
imported in 1912
from Brazil for decoration
then a weed on a mule track
on a losing
pineapple plantation
now an old tree in a line
of old trees
the toad came at night
first and sat in the water
all night and all day
then sometimes at night
left for an outing
but was back in the morning
under the branches among
the ferns the green sword leaf
of the lily
sitting in the water
all the dry months
gazing at the sky
through those eyes
fashioned of the most
precious of metals
come back
believer in shade
believer in silence and elegance

believer in ferns
believer in patience
believer in the rain

    W. S. MERWIN,
    American, b. 1927

**Frog on a Lotus Leaf Eyes Dragonfly.**
Hsiang Sheng-mo, Chinese, 1597–1658.
Leaf from the album *Landscape, Flowers,
and Birds*, 1639; ink and color on paper.

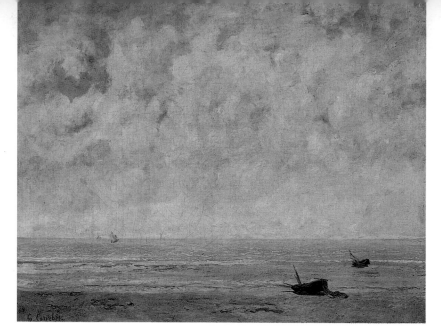

**The Calm Sea.**
Gustave Courbet, French,
1819–1877. Oil on canvas,
1869.

## AUTUMN ON THE BEACHES

Not more blue at the dawn of the world,
  Not more virgin or more gay,
Never in all the million years
  Was the sea happier than to-day.

The sand was not more trackless then,
  Morning more stainless or more cold—
Only the forest and the fields
  Know that the year is old.

SARA TEASDALE, American, 1884–1933

## LOW-ANCHORED CLOUD

Low-anchored cloud,
Newfoundland air,
Fountain-head and source of rivers,
Dew-cloth, dream drapery,
And napkin spread by fays;
Drifting meadow of the air,
Where bloom the daisied banks and violets,
And in whose fenny labyrinth
The bittern booms and heron wades;
Spirit of lakes and seas and rivers,
Bear only perfumes and the scent
Of healing herbs to just men's fields!

HENRY DAVID THOREAU, American, 1817–1862

[ 108 ]

# THE WORLD BELOW THE BRINE

The world below the brine,
Forests at the bottom of the sea, the branches
and leaves,
Sea-lettuce, vast lichens, strange flowers and
seeds, the thick tangle, openings, and pink
turf,
Different colors, pale gray and green, purple,
white, and gold, the play of light through the
water,
Dumb swimmers there among the rocks, coral,
gluten, grass, rushes, and the aliment of the
swimmers,
Sluggish existences grazing there suspended, or
slowly crawling close to the bottom,
The sperm-whale at the surface blowing air and
spray, or disporting with his flukes,
The leaden-eyed shark, the walrus, the turtle,
the hairy sea-leopard, and the sting-ray,
Passions there, wars, pursuits, tribes, sight in
those ocean-depths, breathing that thick-
breathing air, as so many do,
The change thence to the sight here, and to the
subtle air breathed by beings like us who walk
this sphere,
The change onward from ours to that of beings
who walk other spheres.

WALT WHITMAN, American, 1819–1892

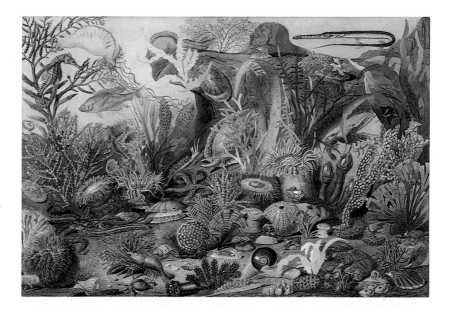

**Ocean Life.** Christian Schuessele, American, 1824/26–1879 and James Sommerville, American, d. 1899. Watercolor, gum arabic, gouache, and graphite on paper.

# A POPULAR PERSONAGE AT HOME

'I live here: "Wessex" is my name:
I am a dog known rather well:
I guard the house; but how that came
To be my whim I cannot tell.

'With a leap and a heart elate I go
At the end of an hour's expectancy
To take a walk of a mile or so
With the folk I let live here with me.

'Along the path, amid the grass
I sniff, and find out rarest smells
For rolling over as I pass
The open fields towards the dells.

'No doubt I shall always cross this sill,
And turn the corner, and stand steady,
Gazing back for my mistress till
She reaches where I have run already,

'And that this meadow with its brook,
And bulrush, even as it appears
As I plunge by with hasty look,
Will stay the same a thousand years.'

Thus 'Wessex.' But a dubious ray
At times informs his steadfast eye,
Just for a trice, as though to say,
'Yet, will this pass, and pass shall I?'

THOMAS HARDY, English, 1840–1928

**Woman with a Parrot.** Édouard Manet,
French, 1832–1883. Oil on canvas, 1866.

**Madame Georges Charpentier
(Marguerite Lemonnier, died 1904) and
Her Children, Georgette (born 1872) and
Paul (1875–1895).** Pierre-Auguste Renoir,
French, 1841–1919. Oil on canvas, 1878.

## TO A PRIZE BIRD

You suit me well, for you can make me laugh,
nor are you blinded by the chaff
    that every wind sends spinning from the rick.

You know to think, and what you think you speak
with much of Samson's pride and bleak
    finality, and none dare bid you stop.

Pride sits you well, so strut, colossal bird.
No barnyard makes you look absurd;
    your brazen claws are staunch against defeat.

MARIANNE MOORE, American, 1887–1972

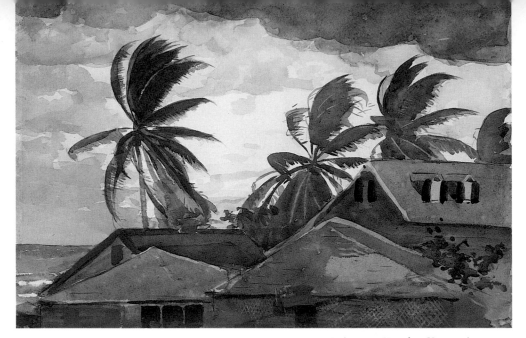

**Hurricane, Bahamas.** Winslow Homer, American, 1836–1910. Watercolor and graphite on paper, 1898.

## HURRICANE

Sleep at noon. Window blind
rattle and bang. Pay no mind.
Door go jump like somebody coming:
let him come. Tin roof drumming:
drum away—she's drummed before.
Blinds blow loose: unlatch the door.
Look up sky through the manchineel:
black show through like a hole in your heel.
Look down shore at the old canoe:
rag-a-tag sea turn white, turn blue,
kick up dust in the lee of the reef,
wallop around like a loblolly leaf.
Let her wallop—who's afraid?
Gale from the north-east: just the Trade . . .

And that's when you hear it: far and high—
sea-birds screaming down the sky
high and far like screaming leaves;
tree-branch slams across the eaves;
rain like pebbles on the ground . . .

and the sea turns white and the wind goes round.

ARCHIBALD MACLEISH, American, 1892–1982

## WATERFALL

It plunges into itself, stone-white, mottled with
    emerald,
And finished falling forever, it goes on
Falling, half rain, to a pool
In bedrock and turns, extravagantly fallen, to
    recover
Its broken channel through maple and maidenhair
But always falling
Again, again, the same water, having been
    meanwhile
Everywhere under the moon, salted and frozen,
Thawed and upraised
Into its cloudy mother-of-pearl feathers to gather
Against the mountains, foregathering its own
And streaming once more

To fall as it must fall at the verge of understanding
In a roaring downpour as strange as this very
    moment
Swept over and over.

> DAVID WAGONER, American, b. 1926

## WATERFALL

Water falls
Apart in air
Hangs like hair
Light installs
Itself in strands
Of water falling
The cliff stands

> SAMUEL MENASHE,
> American, b. 1925

**Underneath Niagara Falls.** Ferdinand Richardt,
American, 1819–1895. Oil on canvas, 1862.

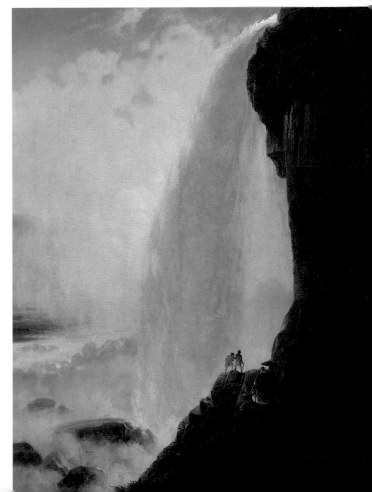

**Trunks of Maple and Birch with Oak Leaves, Passaconaway Road, New Hampshire.** Eliot Porter, American, 1901–1990. Dye transfer print, 1956.

## LES ÉTIQUETTES JAUNES

I picked up a leaf
today from the sidewalk.
This seems childish.

Leaf! you are so big!
How can you change your
color, then just fall!

As if there were no
such thing as integrity!

You are too relaxed
to answer me. I am too
frightened to insist.

Leaf! don't be neurotic
Like the small chameleon.

FRANK O'HARA, American, 1926–1966

## SONNET LXXIII

That time of year thou mayst in me behold,
When yellow leaves, or none, or few, do hang
Upon those boughs which shake against the cold,
Bare ruined choirs, where late the sweet birds
   sang.
In me thou seest the twilight of such day,
As after sunset fadeth in the west,
Which by and by black night doth take away,
Death's second self, that seals up all in rest.

In me thou seest the glowing of such fire,
That on the ashes of his youth doth lie,
As the death-bed whereon it must expire,
Consumed with that which it was nourished by.
   This thou perceiv'st, which makes thy love
     more strong,
   To love that well which thou must leave ere
     long.

WILLIAM SHAKESPEARE, English, 1564–1616

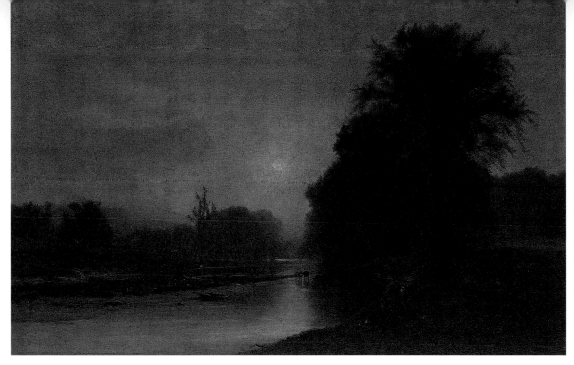

**Autumn Meadows.** George Inness, American,
1825–1894. Oil on canvas, 1869.

## THERE'S NOTHING LIKE THE SUN

There's nothing like the sun as the year dies,
Kind as it can be, this world being made so,
To stones and men and beasts and birds and flies,
To all things that it touches except snow,
Whether on mountain side or street of town.
The south wall warms me: November has begun,
Yet never shone the sun as fair as now
While the sweet last-left damsons from the bough
With spangles of the morning's storm drop down
Because the starling shakes it, whistling what

Once swallows sang. But I have not forgot
That there is nothing, too, like March's sun,
Like April's, or July's, or June's, or May's,
Or January's, or February's, great days:
August, September, October, and December
Have equal days, all different from November.
No day of any month but I have said—
Or, if I could live long enough, should say—
'There's nothing like the sun that shines to-day.'
There's nothing like the sun till we are dead.

EDWARD THOMAS, English, 1878–1917

[ 115 ]

## SPRING AND FALL

To a young child

Márgarét, áre you gríeving
Over Goldengrove unleaving?
Leáves líke the things of man, you
With your fresh thoughts care for, can you?
Áh! ás the heart grows older
It will come to such sights colder
By and by, nor spare a sigh
Though worlds of wanwood leafmeal lie;
And yet you *will* weep and know why.
Now no matter, child, the name:
Sórrow's spríngs áre the same.
Nor mouth had, no nor mind, expressed
What heart heard of, ghost guessed:
It ís the blight man was born for,
It is Margaret you mourn for.

GERARD MANLEY HOPKINS, English, 1844–1889

## TO BE CLOSELY WRITTEN ON A SMALL PIECE OF PAPER WHICH FOLDED INTO A TIGHT LOZENGE WILL FIT ANY GIRL'S LOCKET

Lo the leaves
Upon the new autumn grass—
Look at them well . . .!

WILLIAM CARLOS WILLIAMS, American, 1883–1963

## THE GOLDEN GROVE

Suddenly the golden grove stopped
Talking, and in the breathless silence
Of the birches we could feel the cranes
In sad flight overhead, indifferent
To all of us in the autumn days.

Why should they be? We are all
Pilgrims in the world—The hempfield
And the broad moon over the blue lake
Dream of the past, and I stand alone
On the steppe, thinking of my happy youth,

Regretting nothing I have ever done,
The years spent in vain, nor the lilac
Blossom in my heart. The cranes
Are carried out of sight by the wind,
And in the garden the fire

Of bright red mountain ash
Is burning. But it cannot warm us.
The tassels of the ash will never burn.
And the grass, though brown, never die.
Like a tree that sadly drops its leaves,

I drop sad words, scattered
By the wind. And if time should
Gather them unwanted and unneeded . . .
So be it . . . The golden grove . . .
Talking in soft undertones.

SERGEI ESSENIN, Russian, 1895–1925

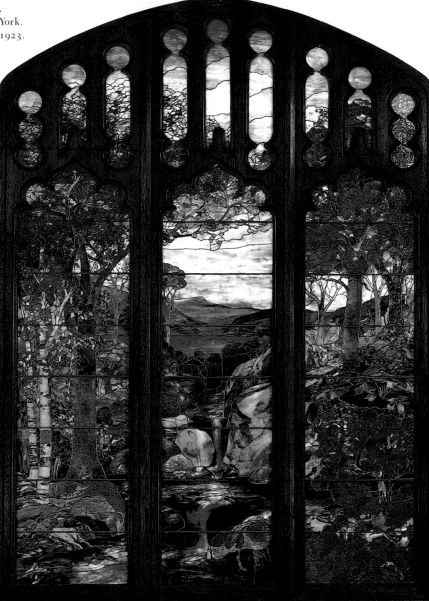

**Autumn Landscape.**
Tiffany Studios, New York.
Leaded-glass window, 1923.

## GOLD

Suddenly all the gold I ever wanted
Let loose and fell on me. A storm of gold
Starting with rain a quick sun catches falling
And in the rain (fall within fall) a whirl
Of yellow leaves, glitter of paper nuggets.

**Chrysanthemums and Sparrows.** Exterior of a writing
box cover; sprinkled gold on lacquer. Japanese, 19th century.

And there were puddles the sun was winking at
And fountains saucy with goldfish, fantails,
    sunfish,
And trout slipping in streams it would be insult
To call gold and, trailing their incandescent
Fingers, meteors and a swimming moon.

Flowers of course. Chrysanthemums and clouds
Of twisted cool witch-hazel and marigolds,
Late dandelions and all the goldenrods.
And bees all pollen and honey, wasps gold-banded
And hornets dangling their legs, cruising the
    sun.

The luminous birds, goldfinches and orioles,
Were gone or going, leaving some of their gold
Behind in near-gold, off-gold, ultra-golden
Beeches, birches, maples, apples. And under
The appletrees the lost, the long-lost names.

Pumpkins and squashes heaped in a cold-gold
    sunset—
Oh, I was crushed like Croesus, Midas-smothered
And I died in a maple-fall a boy was raking
Nightward to burst all bonfire-gold together—
And leave at last in a thin blue prayer of smoke.

ROBERT FRANCIS, American, b. 1901

## PLANTING BAMBOOS

I am not suited for service in a country town;
At my closed door autumn grasses grow.
What could I do to ease a rustic heart?
I planted bamboos, more than a hundred shoots.
When I see their beauty, as they grow by the
    stream-side,
I feel again as though I lived in the hills,
And many a time when I have not much work
Round their railing I walk till night comes.
Do not say that their roots are still weak,
Do not say that their shade is still small;
Already I feel that both in courtyard and house
Day by day a fresher air moves.
But most I love, lying near the window-side,
To hear in their branches the sound of the
    autumn wind.

PO CHÜ-I, Chinese, 772–846

## WANDERER'S NIGHT SONG

Over every peak
There is peace,
In the treetops
You hear
Hardly a breath;
The birds in the forest are silent.
Just wait, soon
You will be peaceful too.

JOHANN WOLFGANG VON GOETHE,
German, 1749–1832

**Finches and Bamboo.**
Emperor Sung Hui-tsung, Chinese,
1082–1135; reigned 1101–1125.
Detail of a handscroll; ink and color
on silk.

## SEEING THE MOONLIGHT

Seeing the moonlight
spilling down
through these trees,
my heart fills to the brim
with autumn.

ONO NO KOMACHI, Japanese, ca. 850

## I CUT IN TWO

I cut in two
A long November night, and
Place half under the coverlet,
Sweet-scented as a spring breeze.
And when he comes, I shall take it out,
Unroll it inch by inch, to stretch the night.

HWANG CHIN-I, Korean, 1506–1544

## BY THE OPEN WINDOW

In the calm of the autumn night
I sit by the open window
For whole hours in perfect
Delightful quietness.
The light rain of leaves falls.
The sigh of the corruptible world
Echoes in my corruptible nature.
But it is a sweet sigh, it soars as a prayer.
My window opens up a world
Unknown. A source of ineffable,
Perfumed memories is offered me;
Wings beat at my window—
Refreshing autumnal spirits
Come unto me and encircle me
And they speak with me in their innocence.
I feel indistinct, far-reaching hopes
And in the venerable silence
Of creation, my ears hear melodies,
They hear crystalline, mystical
Music from the chorus of the stars.

C. P. Cavafy, Greek, 1863–1933

Autumn Grasses. Shibata Zeshin, Japanese, 1807–1891. Panel from a two-fold screen; ink, lacquer, and silver leaf on paper.

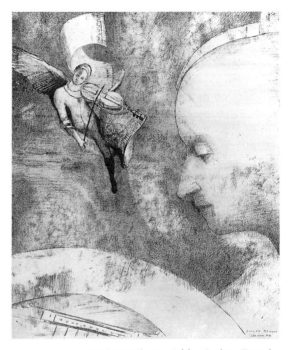

L'Art Céleste. Odilon Redon, French, 1840–1916. Lithograph, 1894.

## NOVEMBER NIGHT

Listen . . .
With faint dry sound,
Like steps of passing ghosts,
The leaves, frost-crisp'd, break from the trees
And fall.

Adelaide Crapsey, American, 1878–1914

## SNOW-FLAKES

Out of the bosom of the Air,
    Out of the cloud-folds of her garments
      shaken,
Over the woodlands brown and bare,
    Over the harvest-fields forsaken,
      Silent, and soft, and slow
      Descends the snow.

Even as our cloudy fancies take
    Suddenly shape in some divine expression,
Even as the troubled heart doth make

In the white countenance confession,
    The troubled sky reveals
    The grief it feels.

This is the poem of the Air,
    Slowly in silent syllables recorded;
This is the secret of despair,
    Long in its cloudy bosom hoarded,
      Now whispered and revealed
      To wood and field.

HENRY WADSWORTH LONGFELLOW, American,
1807–1882

## DECEMBER

      If there were a blessing
outside us
      it would be the falling
of snow
      Evenness
of movement    quiet
of decision
      silence
      A clearness
come,
    a movement
of lightness
      Inside us it grows deeper;
widens

HILDA MORLEY, American, b. 1920

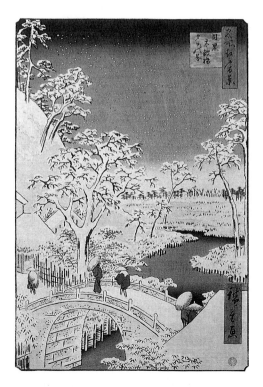

**Meguro Drum Bridge and Sunset Hill.**
Utagawa Hiroshige, Japanese, 1797–1858.
Woodblock print in colors from the series
*One Hundred Famous Views of Edo*, 1857.

# Winter Paradise

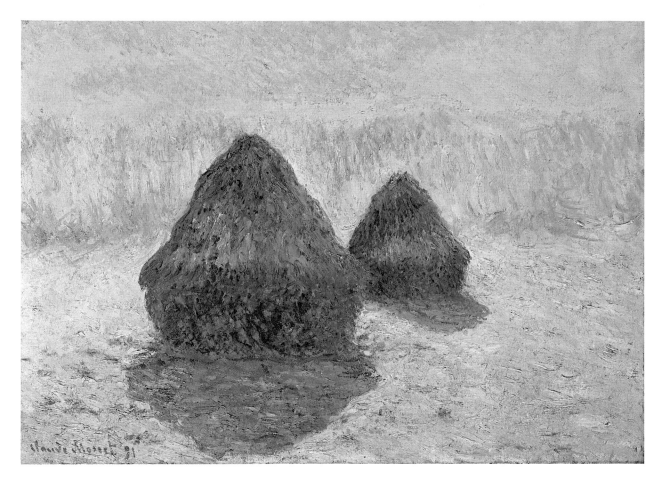

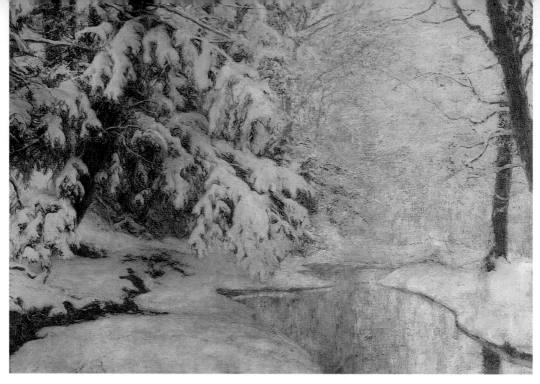

## WINTER PARADISE

Now I am old and free from time
How spacious life,
Unbeginning unending sky where the wind blows
The ever-moving clouds and clouds of starlings
   on the wing,
Chaffinch and apple-leaf across my garden lawn,
Winter paradise
With its own birds and daisies
And all the near and far that eye can see,

Each blade of grass signed with the mystery
Across whose face unchanging everchanging pass
Summer and winter, day and night.
Great countenance of the unknown known
You have looked upon me all my days,
More loved than lover's face,
More merciful than the heart, more wise
Than spoken word, unspoken theme
Simple as earth in whom we live and move.

KATHLEEN RAINE, English, b. 1908

## STAR-GAZING

That I am mortal I know and do confess
My span of day:
           but when I gaze upon
The thousandfold circling gyre of the stars,
No longer do I walk on earth
               but rise
The peer of God himself to take my fill
At the ambrosial banquet of the Undying.

    CLAUDIUS PTOLEMAEUS, Greek-Egyptian,
                    2nd century

## HEAVEN'S RIVER

A lovely thing to see:
      through the paper window's hole,
      the Galaxy.

    ISSA, Japanese, 1763–1827

**The Magic Flute.** Karl Friedrich Thiele, active 1780–1836, Berlin, after Karl Friedrich Schinkel, German, 1781–1841. Set design for the entrance of the Queen of the Night. Hand- and plate-colored aquatint, 1819.

## GOOD NIGHT NEAR CHRISTMAS

And now good night. Good night to this old house
Whose breathing fires are banked for their night's
    rest.
Good night to lighted windows in the west.
Good night to neighbors and to neighbors' cows

Whose morning milk will be beside my door.
Good night to one star shining in. Good night

To earth, poor earth with its uncertain light,
Our little wandering planet still at war.

Good night to one unstarved and gnawing mouse
Between the inner and the outer wall.
He has a paper nest in which to crawl.
Good night to men who have no bed, no house.

    ROBERT FRANCIS, American, b. 1901

## FOR THE NEW YEAR, 1981

I have a small grain of hope—
one small crystal that gleams
clear colors out of transparency.

I need more.

I break off a fragment
to send you.

Please take
this grain of a grain of hope
so that mine won't shrink.

Please share your fragment
so that yours will grow.

Only so, by division,
will hope increase,

like a clump of irises, which will cease to flower
unless you distribute
the clustered roots, unlikely source—
clumsy and earth-covered—
of grace.

     DENISE LEVERTOV, American, b. 1923

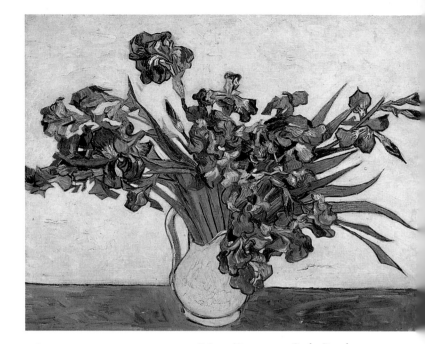

**Irises.** Vincent van Gogh, Dutch,
1853–1890. Oil on canvas, 1890.

**The Brook.** George Luks, American,
1866–1933. Watercolor and pencil on
paper, ca. 1920.

## NOTHING WILL DIE

When will the stream be aweary of flowing
　　Under my eye?
When will the wind be aweary of blowing
　　Over the sky?
When will the clouds be aweary of fleeting?
When will the heart be aweary of beating?
　　And nature die?
Never, oh! never, nothing will die;
　　The stream flows,
　　The wind blows,
　　The cloud fleets,
　　The heart beats,
　　　Nothing will die.

Nothing will die;
All things will change
Thro' eternity.
'Tis the world's winter;
Autumn and summer
Are gone long ago;
Earth is dry to the centre,
But spring, a new comer,
A spring rich and strange,
Shall make the winds blow
Round and round,
Thro' and thro',
　　Here and there,
　　Till the air
And the ground
Shall be fill'd with life anew.

The world was never made;
It will change, but it will not fade.
So let the wind range;
For even and morn
　　Ever will be
　　Thro' eternity.
Nothing was born;
Nothing will die;
All things will change.

ALFRED, LORD TENNYSON, English, 1809–1892

**Snowbound.** Eric Daglish,
British, 1894–1966. Woodcut.

## A GUEST

My woods belong to woodcock and to deer;
For them, it is an accident I'm here.

If, for the plump raccoon, I represent
An ash can that was surely heaven-sent,

The bright-eyed mask, the clever little paws
Obey not mine, but someone else's laws.

The young buck takes me in with a long glance
That says that I, not he, am here by chance.

And they all go their ways, as I must do,
Up through the green and down again to snow,

No one of us responsible or near,
But each himself and in the singular.

When we do meet, I am the one to stare
As if an angel had me by the hair,

As I am flooded by some ancient bliss
Before all I possess and can't possess.

So when a stranger knocks hard at the door,
He cannot know what I am startled for—

To see before me an unfurry face,
A creature like myself in this wild place.

Our wilderness gets wilder every day
And we intend to keep the tamed at bay.

MAY SARTON, American, b. 1912

## HAIKU (SLIGHTLY OVERLENGTH)

Winter has come
Five days of ice storm
The sheep have retreated to the barn
And the dog is allowed into the kitchen
I think of you
And keep warm.

JAMES LAUGHLIN, American, b. 1914

## PINE TREE TOPS

in the blue night
frost haze, the sky glows
with the moon
pine tree tops
bend snow-blue, fade
into sky, frost, starlight.
the creak of boots.
rabbit tracks, deer tracks,
what do we know.

GARY SNYDER, American,
b. 1930

**Deer in the Moonlight.**
William Morris Hunt, American,
1824–1879. Lithograph, 1859.

## OUT IN THE DARK

Out in the dark over the snow
The fallow fawns invisible go
With the fallow doe;
And the winds blow
Fast as the stars are slow.

Stealthily the dark haunts round
And, when the lamp goes, without sound
At a swifter bound
Than the swiftest hound,
Arrives, and all else is drowned;

And star and I and wind and deer,
Are in the dark together,—near,
Yet far,—and fear
Drums on my ear
In that sage company drear.

How weak and little is the light,
All the universe of sight,
Love and delight,
Before the might,
If you love it not, of night.

EDWARD THOMAS, English, 1878–1917

## WINTER NIGHT

My bed is so empty that I keep on waking up;
As the cold increases, the night-wind begins to
blow.
It rustles the curtains, making a noise like the
sea.
Oh that those were waves which could carry me
back to you!

CHIEN WÊN-TI, Chinese, 6th century

**Pheasant Among Pines on Snowy Declivity.**
Utagawa Hiroshige, Japanese, 1797–1858. Woodblock
print in colors.

## THE EVENING STAR

One star in the dark pass of the houses,
Shines as if it were a sign
Set there to point the way to—
But more beautiful, somehow, than what it points
   to,
So that no one has ever gone on beyond
Except those who could not see it, and went on
To what it pointed to, and could not see that
   either.
The star far off separates yet how could I see it
If there were not inside me the same star?

We wish on the star because the star itself is a
   wish,
An unwilling halting place, so far and no farther.
Everything is its own sigh at being what it is
And no more, an unanswered yearning
Toward what will be, or was once perhaps,
Or might be, might have been, or . . .

And so soon after the sun goes, and night comes,
The star has set.

RAINER MARIA RILKE, Austrian, 1875–1926

## THE WINTERS SPRING

The winter comes I walk alone
I want no birds to sing
To those who keep their hearts their own
The winter is the Spring
No flowers to please—no bees to hum
The coming Springs already come

I never want the christmas rose
To come before its time
The seasons each as God bestows
Are simple and sublime
I love to see the snow storm hing
'Tis but the winter garb of Spring

I never want the grass to bloom
The snow-storm's best in white
I love to see the tempest come
And love its piercing light
The dazzled eyes that love to cling
O'er snow white meadows sees the Spring

I love the snow the crimpling snow
That hangs on every thing
It covers every thing below
Like white doves brooding wing
A landscape to the aching sight
A vast expance of dazzling light

**Snow.** Marc Chagall,
French, 1887–1985.
Gouache on cardboard,
ca. 1911.

It is the foliage of the woods
That winter's bring—The dress
White easter of the year in bud
That makes the winter Spring
The frost and snow his poseys bring
Natures white spirits of the Spring

JOHN CLARE, English, 1793–1864

**The Way Home.** Ludwig Michaelek, Austrian,
1859–1942. Color etching and aquatint, 1901.

[ 131 ]

**Chinese Bellflower and Carnations with Insects.** Kitagawa Utamaro, Japanese, 1753–1806. Double-page illustration from *Ehon Mushi Erabi* (*Book of Insects*); colored woodblock print; ca. 1788.

**Arbor and Grotto.** From the wall of a bedroom in the villa of P. Fannius Synistor at Boscoreale. Roman, ca. 40–30 B.C. Fresco on lime plaster.

## ON THE GRASSHOPPER AND CRICKET

The poetry of earth is never dead:
    When all the birds are faint with the hot
      sun,
    And hide in cooling trees, a voice will run
From hedge to hedge about the new-mown mead;
That is the Grasshopper's—he takes the lead
    In summer luxury,—he has never done
    With his delights; for when tired out with
      fun
He rests at ease beneath some pleasant weed.
The poetry of earth is ceasing never:
    On a lone winter evening, when the frost
    Has wrought a silence, from the stove there
      shrills
The Cricket's song, in warmth increasing ever,
    And seems to one in drowsiness half lost,
    The Grasshopper's among some grassy hills.

JOHN KEATS, English, 1795–1821

## SPRING QUIET

Gone were but the Winter,
    Come were but the Spring,
I would go to a covert
    Where the birds sing;

Where in the whitethorn
    Singeth a thrush,
And a robin sings
    In the holly-bush

Full of fresh scents
    Are the budding boughs
Arching high over
    A cool green house;

Full of sweet scents,
    And whispering air
Which sayeth softly:
    'We spread no snare;

'Here dwell in safety,
    Here dwell alone,
With a clear stream
    And a mossy stone.

'Here the sun shinest
    Most shadily;
Here is heard an echo
    Of the far sea,
      Though far off it be.'

CHRISTINA ROSSETTI, English,
        1830–1894

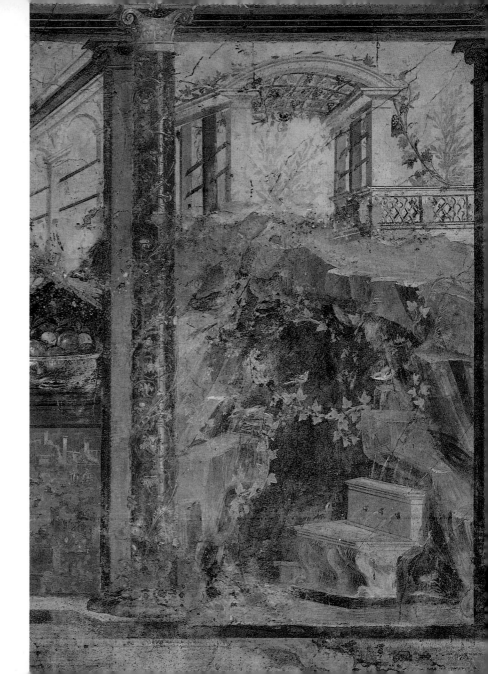

## ABSENCES

It's snowing this afternoon and there are no
    flowers,
There is only this sound of falling, quiet and
    remote,
Like the memory of scales descending the white
    keys
Of a childhood piano—outside the window, palms!
And the heavy head of the cereus, inclining,
Soon to let down its white or yellow-white.

Now, only these poor snow-flowers in a heap,
Like the memory of a white dress cast down . . .
So much has fallen.
                    And I, who have listened for
                    a step
All afternoon, hear it now, but already falling
    away,
Already in memory. And the terrible scales
    descending
On the silent piano; the snow; and the absent
    flowers abounding.

DONALD JUSTICE, American, b. 1925

## RED AND WHITE

Nobody picks a red rose when the winter wind
    howls and the white snow blows among the
    fences and storm doors.
Nobody watches the dreamy sculptures of snow
    when the summer roses blow red and soft in
    the garden yards and corners.

**Two Young Girls at the Piano.**
Pierre-Auguste Renoir, French,
1841–1919. Oil on canvas.

O I have loved red roses and O I have loved white
    snow—
        dreamy drifts winter and summer—roses
        and snow.

CARL SANDBURG, American, 1878–1967

[ 134 ]

# THE SNOW IS DEEP ON THE GROUND

The snow is deep on the ground.
Always the light falls
Softly down on the hair of my belovèd.

This is a good world.
The war has failed.
God shall not forget us.
Who made the snow waits where love is.

Only a few go mad.
The sky moves in its whiteness
Like the withered hand of an old king.
God shall not forget us.
Who made the sky knows of our love.

The snow is beautiful on the ground.
And always the lights of heaven glow
Softly down on the hair of my belovèd.

KENNETH PATCHEN, American, 1911–1972

**Winter in Union Square.** Childe Hassam, American, 1859–1935. Oil on canvas, 1890.

## THE BARE TREE

My mother once said to me, "When one sees the tree in leaf one thinks the beauty of the tree is in its leaves, and then one sees the bare tree."

SAMUEL MENASHE, American, b. 1925

## LOST

Stand still. The trees ahead and bushes beside
   you
Are not lost. Wherever you are is called Here,
And you must treat it as a powerful stranger,
Must ask permission to know it and be known.
The forest breathes. Listen. It answers,
I have made this place around you.
If you leave it, you may come back again, saying
   Here.
No two trees are the same to Raven.
No two branches are the same to Wren.
If what a tree or a bush does is lost on you,
You are surely lost. Stand still. The forest knows
Where you are. You must let it find you.

DAVID WAGONER, American, b. 1926

**The Birches.** Neil Welliver, American, b. 1929. Oil on canvas, 1977.

**Sports on a Frozen River.** Aert van der Neer, Dutch, 1603/4–1677. Oil on wood.

## THE NIGHT SKATER

Relishing this health, this singleness,
I reach myself out along the surface of a crystal
that cleaves clear down to my own cold roots.
I am the chill wind, passing . . .

How simple this motion, how free of life and
    death,
how like a god's in his changing!
It fathoms me: ten thousand stars have scattered
glistenings of midnight all along my veins.

FREDERICK MORGAN, American, b. 1922

## LIKE QUEEN CHRISTINA

Orange and blue and then grey
The frosty twilight comes down
Through the thin trees. The fresh snow
Holds the light longer than the sky.
Skaters on the pond vanish
In dusk, but their voices stay,
Calling and laughing, and birds
Twitter and cry in the reeds.
Indoors as night fills the white rooms,
You stand in the candle light
Laughing like a splendid jewel.

KENNETH REXROTH, American, 1905–1982

**The Houses of Parliament
(Effect of Fog).** Claude Monet,
French, 1840–1926. Oil on canvas,
1903.

## THE MIST

I am the mist, the impalpable mist,
Back of the thing you seek.
My arms are long,
Long as the reach of time and space.

Some toil and toil, believing,
Looking now and again on my face,
Catching a vital, olden glory.

But no one passes me,
I tangle and snare them all.
I am the cause of the Sphinx,
The voiceless, baffled, patient Sphinx.

I was at the first of things,
I will be at the last.
    I am the primal mist
    And no man passes me;
    My long impalpable arms
    Bar them all.

CARL SANDBURG, American, 1878–1967

## HERE

My steps along this street
resound
        in another street
in which
      I hear my steps
passing along this street
in which

Only the mist is real

OCTAVIO PAZ, Mexican, b. 1914

## POEMA DEL CITY 2

A light chill on the knees
& I sneeze
up late, alone, in my house, winter
rain against the window and glittering there
in the constant light from stoops across
the street
cars hiss down from one moment to
the next hour: in an hour
I'll be asleep. Wrapped
in new sheets and old quilts
with my wife warm beside me and my son
asleep in the next room, I'll
be so comfortable and dreamy, so happy
I'm not terribly damaged or dying yet
but sailing, secure, secret and all
those other peaceful s's fading
like warm tail lights down a long landscape
with no moon at all.
         Ah, it's sweet,
this living, to make you cry, or rise
& sneeze, and douse the light.

RON PADGETT, American, b. 1942

## WINTER DOWNPOUR

Winter downpour—
even the monkey
needs a raincoat.

BASHŌ, Japanese, 1644–1694

**The Flatiron, 1904.** Edward Steichen, American (b. Luxembourg), 1879–1973. Blue-green pigment gum-bichromate over platinum, 1909.

**Tables for Ladies.** Edward Hopper, American, 1882–1967. Oil on canvas, 1930.

## THE TROPICS IN NEW YORK

Bananas ripe and green, and ginger-root,
Cocoa in pods and alligator pears,
And tangerines and mangoes and grapefruit,
Fit for the highest prize at parish fairs,

Set in the window, bringing memories
Of fruit-trees laden by low-singing rills,

And dewy dawns, and mystical blue skies
In benediction over nun-like hills.

My eyes grew dim, and I could no more gaze;
A wave of longing through my body swept,
And, hungry for the old, familiar ways,
I turned aside and bowed my head and wept.

CLAUDE MCKAY, American (b. Jamaica), 1890–1948

[ 140 ]

## DESIRE FOR SPRING

Calcium days, days when we feed our bones!
Iron days, which enrich our blood!
Saltwater days, which give us valuable iodine!
When will there be a perfectly ordinary spring
    day?
For my heart needs to be fed, not my urine
Or my brain, and I wish to leap to Pittsburgh
From Tuskegee, Indiana, if necessary, spreading
    like a flower
In the spring light, and growing like a silver
    stair.
Nothing else will satisfy me, not even death!
Not even broken life insurance policies, cancer,
    loss of health,
Ruined furniture, prostate disease, headaches,
    melancholia,
No, not even a ravaging wolf eating up my flesh!
I want spring, I want to turn like a mobile
In a new fresh air! I don't want to hibernate
Between walls, between halls! I want to bear
My share of the anguish of being succinctly here!
Not even moths in the spell of the flame
Can want it to be warmer so much as I do!
Not even the pilot slipping into the great green
    sea
In flames can want less to be turned to an icicle!
Though admiring the icicle's cunning, how shall
    I be satisfied
With artificial daisies and roses, and wax pears?

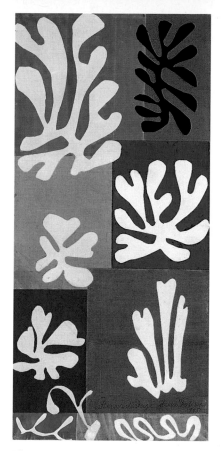

**Snow Flowers.** Henri Matisse, French, 1869–1954.
Watercolor and gouache, on cut-and-pasted papers, 1951.

O breeze, my lovely, come in, that I mayn't be
    stultified!
Dear coolness of heaven, come swiftly and sit in
    my chairs!

KENNETH KOCH, American, b. 1925

# GOD'S GRANDEUR

The world is charged with the grandeur of God.
    It will flame out, like shining from shook
      foil;
    It gathers to a greatness, like the ooze of oil
Crushed. Why do men then now not reck his
    rod?
Generations have trod, have trod, have trod;
    And all is seared with trade; bleared, smeared
      with toil;
    And wears man's smudge and shares man's
      smell: the soil
Is bare now, nor can foot feel, being shod.

And for all this, nature is never spent;
    There lives the dearest freshness deep down
      things;
And though the last lights off the black West
    went
    Oh, morning, at the brown brink eastward,
      springs—
Because the Holy Ghost over the bent
    World broods with warm breast and with
      ah! bright wings.

GERARD MANLEY HOPKINS, English, 1844–1889

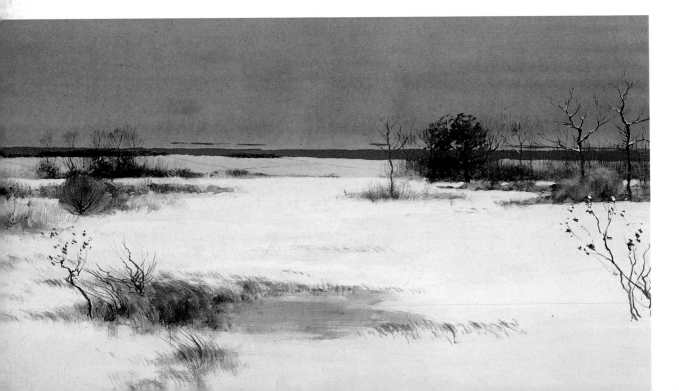

# UNSEEN BUDS

Unseen buds, infinite, hidden well,
Under the snow and ice, under the darkness, in
  every square or cubic inch,
Germinal, exquisite, in delicate lace, microscopic,
  unborn,
Like babes in wombs, latent, folded, compact,
  sleeping;
Billions of billions, and trillions of trillions of
  them waiting,
(On earth and in the sea—the universe—the
  stars there in the heavens,)
Urging slowly, surely forward, forming endless,
And waiting ever more, forever more behind.

WALT WHITMAN, American, 1819–1892

# TEN THOUSAND FLOWERS IN
SPRING, THE MOON IN AUTUMN

Ten thousand flowers in spring, the moon in
  autumn,
a cool breeze in summer, snow in winter.
If your mind isn't clouded by unnecessary things,
this is the best season of your life.

WU-MEN, Chinese, 1183–1260

**Youth Holding a Jasmine Spray.**
Chinese, K'ang-hsi period, 1662–1722. Detail of a
leaf from an album of nineteen paintings; color on silk.

**Snow Scene.** Bruce Crane, American, 1857–1937.
Watercolor and gouache on blue-gray wove paper.

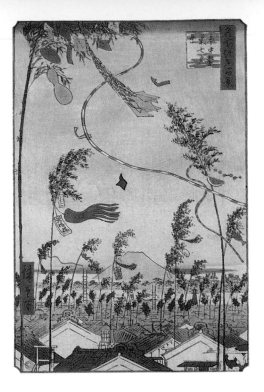

## AND IT WAS WINDY WEATHER

Now the winds are riding by;
Clouds are galloping the sky;

Bush and tree are lashing bare,
Savage boughs on savage air;

Crying, as they lash and sway,
—Pull the roots out of the clay!

Lift away: away:
Away!

Leave security, and speed
From the root, the mud, the mead!

Into sea and air, we go!
To chase the gull, the moon!—and know

—Flying high!
Flying high!—

All the freedom of the sky!
All the freedom of the sky!

JAMES STEPHENS, Irish, 1882–1950

## WHO HAS SEEN THE WIND?

Who has seen the wind?
    Neither I nor you:
But when the leaves hang trembling
    The wind is passing thro'.

Who has seen the wind?
    Neither you nor I:
But when the trees bow down their heads
    The wind is passing by.

CHRISTINA ROSSETTI, English, 1830–1894

**The City Flourishing, Tanabata Festival.**
Utagawa Hiroshige, Japanese, 1797–1858.
Woodblock print in colors from the series *One Hundred Famous Views of Edo*, 1857.

# DEAR MARCH—COME IN

Dear March—Come in—
How glad I am—
I hoped for you before—

Put down your Hat—
You must have walked—
How out of Breath you are—
Dear March, how are you, and the Rest—
Did you leave Nature well—
Oh March, Come right up stairs with me—
I have so much to tell—

I got your Letter, and the Birds—
The Maples never knew that you were coming
     —till I called
I declare—how Red their Faces grew—
But March, forgive me—and
All those Hills you left for me to Hue—
There was no Purple suitable—
You took it all with you—

Who knocks? That April.
Lock the Door—
I will not be pursued—
He stayed away a Year to call
When I am occupied—
But trifles look so trivial
As soon as you have come

That Blame is just as dear as Praise
And Praise as mere as Blame—

EMILY DICKINSON, American, 1830–1886

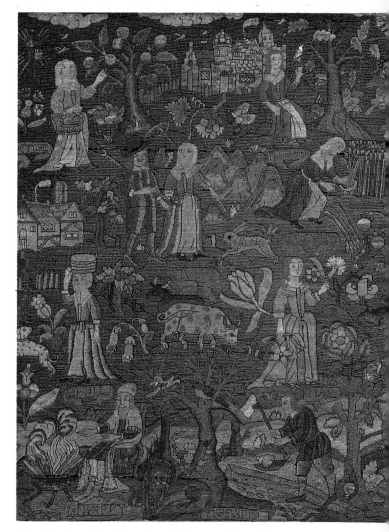

**The Months of the Year.** Detail of an embroidered picture.
English, second quarter of the 17th century. Wool, silk, silver
thread, and purl on canvas.

[ 145 ]

## THIS MORNING

This morning was something. A little snow
lay on the ground. The sun floated in a clear
blue sky. The sea was blue, and blue-green,
as far as the eye could see.
Scarcely a ripple. Calm. I dressed and went
for a walk—determined not to return
until I took in what Nature had to offer.
I passed close to some old, bent-over trees.
Crossed a field strewn with rocks
where snow had drifted. Kept going
until I reached the bluff.
Where I gazed at the sea, and the sky, and
the gulls wheeling over the white beach
far below. All lovely. All bathed in a pure
cold light. But, as usual, my thoughts
began to wander. I had to will
myself to see what I was seeing
and nothing else. I had to tell myself *this* is what
mattered, not the other. (And I did see it,
for a minute or two!) For a minute or two
it crowded out the usual musings on
what was right, and what was wrong—duty,
tender memories, thoughts of death, how I should
   treat
with my former wife. All the things
I hoped would go away this morning.
The stuff I live with every day. What

**Green Sea.** Milton Avery, American,
1885–1965. Oil on canvas, 1954.

I've trampled on in order to stay alive.
But for a minute or two I did forget
myself and everything else. I know I did.
For when I turned back I didn't know
where I was. Until some birds rose up
from the gnarled trees. And flew
in the direction I needed to be going.

RAYMOND CARVER, American, 1938–1988

[ 146 ]

## VACANCY IN THE PARK

March . . . Someone has walked across the snow,
Someone looking for he knows not what.

It is like a boat that has pulled away
From a shore at night and disappeared.

It is like a guitar left on a table
By a woman, who has forgotten it.

It is like the feeling of a man
Come back to see a certain house.

The four winds blow through the rustic arbor,
Under its mattresses of vines.

WALLACE STEVENS, American, 1879–1955

**Washington Square, Winter, 1954.** André Kertész,
American (b. Hungary), 1894–1985. Gelatin silver print,
ca. 1978.

**The Stop-over.** Roy Martell Mason, American, 1886–1972. Watercolor on paper, 1956.

## WILD GEESE

You do not have to be good.
You do not have to walk on your knees
for a hundred miles through the desert, repenting.
You only have to let the soft animal of your body
  love what it loves.
Tell me about despair, yours, and I will tell you
  mine.
Meanwhile the world goes on.
Meanwhile the sun and the clear pebbles of the
  rain
are moving across the landscapes,
over the prairies and the deep trees,
the mountains and the rivers.
Meanwhile the wild geese, high in the clean blue
  air,
are heading home again.
Whoever you are, no matter how lonely,
the world offers itself to your imagination,
calls to you like the wild geese, harsh and
  exciting—
over and over announcing your place
in the family of things.

MARY OLIVER, American, b. 1935

[ 148 ]

# TRANSPLANTING

Watching hands transplanting,
Turning and tamping,
Lifting the young plants with two fingers,
Sifting in a palm-full of fresh loam,—
One swift movement,—
Then plumping in the bunched roots,
A single twist of the thumbs, a tamping and
    turning,
All in one,
Quick on the wooden bench,
A shaking down, while the stem stays straight,
Once, twice, and a faint third thump,—
Into the flat-box it goes,
Ready for the long days under the sloped glass:

The sun warming the fine loam,
The young horns winding and unwinding,
Creaking their thin spines,
The underleaves, the smallest buds
Breaking into nakedness,
The blossoms extending
Out into the sweet air,
The whole flower extending outward,
Stretching and reaching.

THEODORE ROETHKE, American, 1908–1963

**Side of a Greenhouse.** George C. Lambdin, American,
1830–1896. Oil on canvas, ca. 1870–80.

**Tale à la Hoffmann.** Paul Klee, German, 1879–1940.
Watercolor, pencil, and transferred printing ink on paper,
bordered with metallic foil, 1921.

## LANDSCAPE

I want to compose pure poetry
Lying down near the sky, as astrologers do;
Up there, next to bell towers, I'll listen in my
    dreams
To their solemn hymns carried by the wind.
Chin resting in hands, looking down from my
    garrett,
I'll see workers sing and gossip;
Chimneys, steeples—those masts of the city—
And vast skies that tell of eternity.

How sweet, through the mist, to see the birth
Of a star in the blue, a lamp at a window,
Rivers of smoke rising to heaven,
And the moon pouring down her pale
    enchantment.
I'll see springs, summers, autumns,
And when winter comes with monotonous snows,
I'll close all windows and shutters
And build my magic palace in the darkness.
I'll dream of bluish horizons,
Of gardens, of fountains weeping on alabaster,
Of kisses, birds singing night and day,
And everything that belongs in a childish story.
Trouble, knocking vainly at my window,
Won't budge me from my desk
Once I've plunged into those delicious depths
Creating Spring with my will,
Drawing a sun from my heart, and turning
My burning thoughts into mild weather.

    Charles Baudelaire, French, 1821–1867

**Figures in a Persian Garden.** Persian (Isfahan), first quarter of the 17th century. Tile wall panel; composite body, glaze-painted.

## ALL THAT'S PAST

Very old are the woods;
　　And the buds that break
Out of the brier's boughs,
　　When March winds wake,
So old with their beauty are—
　　Oh, no man knows
Through what wild centuries
　　Roves back the rose.

Very old are the brooks;
　　And the rills that rise
Where snow sleeps cold beneath
　　The azure skies
Sing such a history
　　Of come and gone,
Their every drop is as wise
　　As Solomon.

Very old are we men;
　　Our dreams are tales
Told in dim Eden
　　By Eve's nightingales;
We wake and whisper awhile,
　　But, the day gone by,
Silence and sleep like fields
　　Of amaranth lie.

WALTER DE LA MARE, English,
1873–1956

[ 151 ]

## BEFORE SPRING THERE ARE DAYS LIKE THESE

Before spring there are days like these:
Under the dense snow the meadow rests,
The trees merrily, drily rustle,
And the warm wind is tender and supple.
And the body marvels at its lightness,
And you don't recognize your own house,
And that song you were tired of before,
You sing like a new one, with deep emotion.

    ANNA AKHMATOVA, Russian, 1889–1966

## THAW

Over the land freckled with snow half-thawed
The speculating rooks at their nests cawed
And saw from elm-tops, delicate as flower of
    grass,
What we below could not see, Winter pass.

    EDWARD THOMAS, English, 1878–1917

**The Green Car.** William Glackens, American,
1870–1938. Oil on canvas, 1910.

## THANKS TO FLOWERS

Not only the cultivated ones in parks
And gardens, unfolding immaculate petals
On a terrace or trellis, and not just
The wild ones, kissed by elegant birds
In jungle foliage, or brightening roadsides
And meadows, blossoming anyplace that anything
Can blossom, but thanks also to flowers
Blooming in paintings, on carpets, pottery,
Fabrics of dresses and draperies or wherever
The real or invented colors and shapes
Of flowers lift the mood of a scene,
As they are snipped from bushes, gathered
In careless bunches, tied in ribbons
Or arranged in rare bouquets for precious vases;
Perfect by nature for gift and centerpiece,
They perfume ballrooms, backyards and prairies,
And, indoors or out the window, they gladden
Celebrations and refresh every country
And season, for, even in iciest winter,
The word *flower* thrives in every language,
Adorning what everyone says and imagines
With the beautiful thought of flowers
Which teach by timeless example
That life goes by anyway; you might as well
Flower.

    Kate Farrell, American, b. 1946

**Poppies in a Vase.** Pierre Bonnard, French,
1867–1947. Oil on canvas, 1926.

# ANOTHER SPRING

The seasons revolve and the years change
With no assistance or supervision.
The moon, without taking thought,
Moves in its cycle, full, crescent, and full.

The white moon enters the heart of the river;
The air is drugged with azalea blossoms;
Deep in the night a pine cone falls;
Our campfire dies out in the empty mountains.

**Pink Azalea—Chinese Vase.** William Merritt Chase,
American, 1849–1916. Oil on panel, 1880–90.

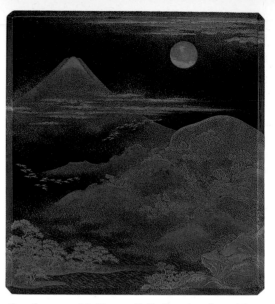

**Landscape with Mount Fuji.** Exterior of a writing
box cover; sprinkled gold on lacquer. Japanese, early
19th century.

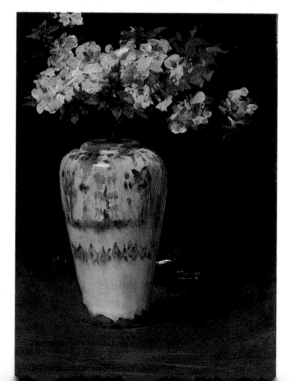

The sharp stars flicker in the tremulous branches;
The lake is black, bottomless in the crystalline
      night;
High in the sky the Northern Crown
Is cut in half by the dim summit of a snow peak.

O heart, heart, so singularly
Intransigent and corruptible,
Here we lie entranced by the starlit water,
And moments that should each last forever

Slide unconsciously by us like water.

KENNETH REXROTH, American, 1905–1982

## THE STOLEN BRANCH

In the night we shall go in
to steal
a flowering branch.

We shall climb over the wall
in the darkness of the alien garden,
two shadows in the shadow.

Winter is not yet gone,

and the apple tree appears
suddenly changed
into a cascade of fragrant stars.

In the night we shall go in
up to its trembling firmament,
and your little hands and mine
will steal the stars.

And silently,
to our house,
in the night and the shadow,
with your steps will enter
perfume's silent step
and with starry feet
the clear body of spring.

PABLO NERUDA, Chilean,
1904–1973

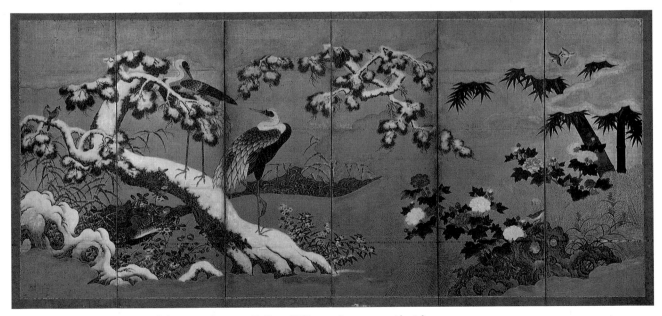

**Birds and Flowers of the Four Season: Fall and Winter.** Japanese, mid-16th century,
Momoyama period. One of a pair of six-fold screens; ink, color, and gold leaf on paper.

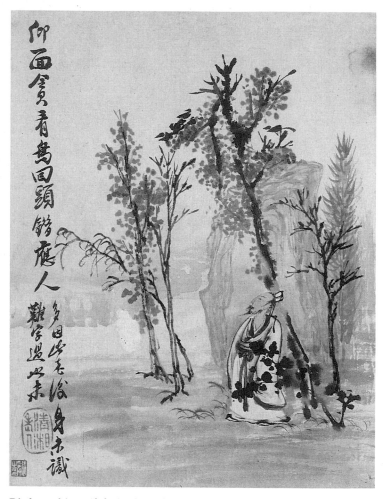

**Birdwatching.** Shih-t'ao (Tao-chi), Chinese, 1642–1707. Leaf from the album *Wilderness Colors*, ca. 1697–1700; ink and color on paper.

## TAO-CHI

Dressed in his long, white, long-sleeved,
blue-sashed holiday robe,
with a fashionably wispy beard
and some kind of Confucian doodad
on his head (it looks like a lantern),
the poet stands, face slightly tilted
upward, in the little grove.
It is just the first month of spring.
Yellow blossoms have appeared
on some of the branches. Others
are still bare. He is probably watching
the four or five black birds perched
on the central tree. Or perhaps
he is looking across to the left-hand
side of the page where, ending
a quote from Tu Fu, the character
for *human being* is inscribed
in two breathtakingly elegant
brush strokes. The ground is marshy.
A light wind rustles his robe.
Suddenly, with a shock, he realizes
that nothing in this life—nothing—
nothing—is ever lost.

STEPHEN MITCHELL, American, b. 1943

[156]

## HOW CAN WE EVER LOSE INTEREST IN LIFE?

How can we ever lose interest in life?
    Spring has come again
And cherry trees bloom in the mountains.

   RYŌKAN, Japanese, 1758–1831

## THE YEAR'S AT THE SPRING

The year's at the spring,
And day's at the morn;
Morning's at seven;
The hill-side's dew-pearled;
The lark's on the wing;
The snail's on the thorn;
God's in His Heaven—
All's right with the world!

   ROBERT BROWNING, English, 1812–1889

**The Beeches.** Asher Brown Durand, American, 1796–1886. Oil on canvas, 1845.

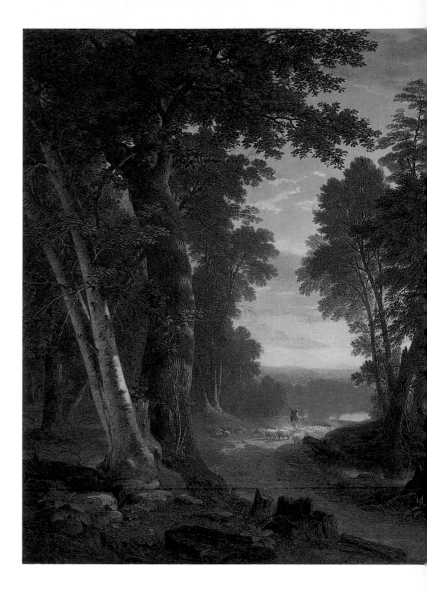

# ACKNOWLEDGMENTS

Grateful acknowledgment is made to the following for permission to print the copyrighted material listed below. Every effort has been made to contact the original copyright holders of the materials included.

*Atlantic Monthly Press:* "Wild Geese" from *Dream Work* by Mary Oliver. Copyright © 1986 by Mary Oliver. Reprinted by permission of the Atlantic Monthly Press. "Waterfall" from the book *Through The Forest* by David Wagoner. Copyright © 1987 by David Wagoner. Reprinted by permission of the Atlantic Monthly Press.

*Peter Blue Cloud:* "Summer Solstice" excerpted from "Within the Seasons" by Peter Blue Cloud (Aroniawenrate), Mohawk of Kahnawake. Reprinted by permission of the author.

*Robert Bly:* "Casida of the Rose" by Federico García Lorca, translated by Robert Bly, from *News of the Universe: Poems of Twofold Consciousness*, chosen and introduced by Robert Bly, Sierra Club Books, 1980. Reprinted by permission of Robert Bly. "Dusk in the Country" and "The Earthworm" by Harry Edmund Martinson, translated by Robert Bly from *Friends, You Drank Some Darkness: Three Swedish Poets* by Robert Bly, Beacon Press, 1975. Reprinted by permission of Robert Bly.

*BOA Editions Limited:* "From Blossoms" copyright © 1986. Reprinted from *Rose* by Li-Young Lee with permission of BOA Editions, Ltd., 92 Park Ave., Brockport, NY 14420.

*Ruth Bogin:* "Docility" by Jules Supervielle. Reprinted with permission of the Estate of George Bogin (first appeared in *Selected Poems and Reflections on the Art of Poetry*, translated from the French by George Bogin), copyright © 1985 by George Bogin.

*Georges Borchardt, Inc:* "Autumn" by Ngo Chi Lan, in *Selected Translations 1948–1968* (New York: Atheneum). Copyright © 1968 by W. S. Merwin.

*Jonathan Cape Limited:* "Leisure" by W. H. Davies from *The Complete Poems of W. H. Davies* (London: Jonathan Cape Ltd.). "Happiness Makes Up in Height for What It Lacks in Length" by Robert Frost from *The Poetry of Robert Frost*, edited by Edward Connery Lathem, reprinted by permission of the Estate of Robert Frost, the editors, and Jonathan Cape Ltd.

*Carcanet Press Limited:* "Heat" by H. D. (Hilda Doolittle) from *Collected Poems*. Reprinted by permission of Carcanet Press Ltd. "In the Fields" by Charlotte Mew from *Collected Poems and Prose*. Reprinted by permission of Carcanet Press Ltd. "Here" by Octavio Paz from *Collected Poems*. Reprinted by permission of Carcanet Press Ltd. "October" by James Schuyler from *Selected Poems*. Reprinted by permission of Carcanet Press Ltd. "The Act," "The Corn Harvest," and "To Be Closely Written on a Small Piece of Paper Which Folded into a Tight Lozenge Will Fit Any Girl's Locket" by William Carlos Williams from *Collected Poems*. Reprinted by permission of Carcanet Press Ltd.

*Copper Canyon Press:* "Too Much Heat, Too Much Work" by Tu Fu from *Carrying Over: Poems from the Chinese, Urdu, Macedonian, Yiddish, and French African*. Copyright © Carolyn Kizer, 1988. Reprinted by permission of Copper Canyon Press.

*Doubleday:* "Heaven's River" by Issa from *An Introduction To Haiku* by Harold G. Henderson. Copyright © 1958 by Harold G. Henderson. Reprinted by permission of Doubleday, a division of Bantam Doubleday Dell Publishing Group, Inc. "Transplanting" copyright 1948 by Theodore Roethke from *The Collected Poems of Theodore Roethke* by Theodore Roethke. Reprinted by permission of Doubleday, a division of Bantam Doubleday Dell Publishing Group, Inc.

*The Ecco Press:* "By the Peonies" by Czeslaw Milosz from *The Collected Poems 1931–1987*, copyright © 1988 by Czeslaw Milosz Royalties, Inc. Published by the Ecco Press in 1988, and reprinted by permission.

*Faber and Faber Limited:* "This Lunar Beauty" and "Their Lonely

# CREDITS

## Fall, Leaves, Fall

## Winter Paradise

# INDEX OF ARTISTS

# INDEX OF AUTHORS AND TITLES

# INDEX OF FIRST LINES

# TRANSLATORS

Akhenaton, "Beautiful You Rise upon the Horizon of Heaven": J. E. Manchip White.

Anna Akhmatova, "The Smell of Blue Grapes Is Sweet . . . and "Before Spring There Are Days like These": Judith Hemschemeyer.

Anonymous, Chippewa Indian, "Spring Song": Frances Densmore.

Anonymous, Navajo Indian, "In Beauty May I Walk": Jerome K. Rothenberg.

Anonymous, Papago Indian, "The Wind Blows from the Sea": Frances Densmore.

Juan de Arguijo, "The Storm and the Calm": Kate Farrell.

Bashō, "Winter Downpour" and "Cherry Blossoms": Lucien Stryk.

Charles Baudelaire, "Landscape": Kate Farrell.

Jorge Luis Borges, "Ars Poetica": Harold Morland.

C. P. Cavafy, "By the Open Window": Rae Dalven.

Chan Fang-shêng, "Sailing Homeward": Arthur Waley.

Chien Wên-ti, "Winter Nights": Arthur Waley.

Sergei Essenin, "The Golden Grove": R. A. D. Ford.

Federico García Lorca, "Casida of the Rose": Robert Bly.

Johann Wolfgang von Goethe, "Allegory" and "Wanderer's Night Song": John White.

Hermann Hesse, "Page from a Journal": Rika Lesser.

Friedrich Hölderlin, "Half of Life": John White.

Hwang Chin-i, "I Cut in Two": Peter H. Lee.

Issa, "Heaven's River": Harold G. Henderson.

Giacomo Leopardi, "The Infinite": William Jay Smith.

Li-Po, "You Ask Why": Sam Hamill.

Lu Yün, "The Valley Wind": Arthur Waley.

Mao Tse-Tung, "The Day of Chung Yang": Ma Wen-Yee.

Harry Edmund Martinson, "Dusk in the Country" and "The Earthworm": Robert Bly.

Czeslaw Milosz, "By the Peonies": Czeslaw Milosz.

Eugenio Montale, "The Sunflower": Kate Farrell.

Edward Mörike, "It's Spring!": John White.

Pablo Neruda, "The Stolen Branch": Donald D. Walsh.

Ngo Chi Lan, "Autumn": W. S. Merwin with Nguyen Ngoc Bich.

Ono no Komachi, "Seeing the Moonlight": Jane Hirshfield with Mariko Aratani.

Octavio Paz, "Here": Charles Tomlinson.

Po Chü-i, "Planting Bamboos": Arthur Waley.

Jacques Prévert, "To Make the Portrait of a Bird": Harriet Zinnes.

Claudius Ptolemaeus, "Star-Gazing": Dudly Fitts.

Rainer Maria Rilke, "The Evening Star": Randall Jarrell.

Rainer Maria Rilke, "Autumn Day" and "Rose, Oh Pure Contradiction": Stephen Mitchell.

Ryōkan, "First Days of Spring": Stephen Mitchell.

Ryōkan, "How Can We Ever Lose Interest in Life?": John Stevens.

Masaoka Shiki, "Fresh from the Void": Kenneth Rexroth.

Jules Supervielle, "Docility": George Bogin.

T'ao Ch'ien, "Reading the Book of Hills and Seas": Arthur Waley.

Tu Fu, "Too Much Heat, Too Much Work": Carolyn Kizer.

Paul Verlaine, "The Sky Rises Above the Rooftop": Kate Farrell.

Virgil, "The Gravid Mares": David R. Slavitt.

Wu Men, "Ten Thousand Flowers in Spring, the Moon in Autumn": Stephen Mitchell.

Yevgeny Yevtushenko, "Perfection": Tina Tupinkina-Glaessner, Geoffrey Dutton, and Igor Mezhakoff-Koriakin.

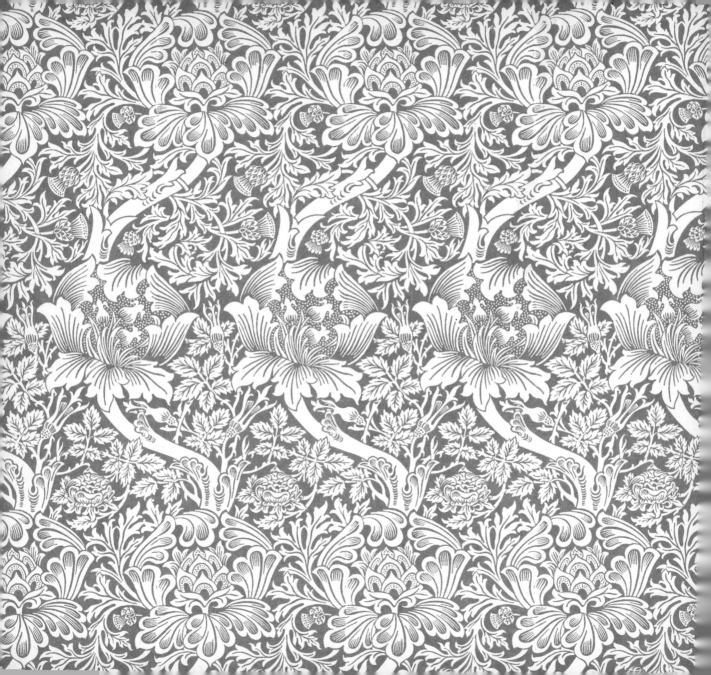